Arts: A Second Level Course

The Age of Revolutions Units 29–30

Art and Politics in France

Prepared by Aaron Scharf for the Arts Second Level Course Team

The Open University Press

The Open University Press
Walton Hall Bletchley Bucks

First published 1972
Copyright © 1972 The Open University

Designed by the Media Development Group of the Open University.

Printed in Great Britain by
EYRE AND SPOTTISWOODE LIMITED
AT GROSVENOR PRESS PORTSMOUTH

SBN 335 00574 8

This text forms part of the correspondence element of an Open University Second Level Course. The complete list of units in the course is given at the end of this text.

For general availability of supporting material referred to in this text, please write to the Director of Marketing, The Open University, Walton Hall, Bletchley, Bucks.

Further information on Open University courses may be obtained from the Admissions Office, The Open University, P.O. Box 48, Bletchley, Bucks.

INTRODUCTION

In the context of a society beset with revolutions and counter-revolutions, like that of France towards the end of the eighteenth and in the first half of the nineteenth century, it would be surprising indeed if there were no direct response to political events by artists. Not all artists of course, sprang to the defence of their social and political ideals. Indeed, not all artists had social and political ideals. For a variety of reasons many preferred to dissociate their art, if not themselves, from the unsettling events of a society in turmoil if not in transition. This, as we can guess, was sometimes out of economic expediency, or because of an active repugnance for violence, or from timidity, or sheer social vacuousness. But it is entirely to be expected that other artists, out of conviction – or even emotion – gave their art to one or another cause, quite willingly turning it into propaganda. It has been fashionable to turn one's nose up at art which aspires to political ends. We must admit that this is often done with good reason, considering the low level of so much political art in the last three or four decades, notwithstanding some notable exceptions. But there is no more convincing reason why an artist dedicated to a political ideal must axiomatically be inferior as an artist, than that an artist dedicated to art alone must be a superior one.

In those insurrectionary days of the French revolutions, when the meanings of patriotism and sedition fluctuated with each alternation of the political pendulum, it was a risky business to declare your faith in a single brand of politics. Artists often went to prison or were heavily fined for their audacity, David and Daumier among them. But who can say that their political convictions contributed nothing to their capabilities as artists?

My purpose, then, in writing Units 29 and 30, is essentially this:
to show the many ways that art, in a period of revolution, was consciously deployed as an instrument of propaganda, and to demonstrate how the techniques and formal styles of art were used to reinforce the message.

I shall deal mainly with artists whose involvement with politics was direct and unambiguous. However, it must be kept in mind that the succession of political tremors which convulsed the period gave rise, I believe, to a spirit of rebelliousness which much contemporary art reflected, not overtly, in terms of subject matter, but in the mood conveyed by the work, even in the handling, and in the expression of individualism which is characteristic of so much art from that time.

The question of style and appropriateness inevitably arises. Was the neoclassical style of painting: lucid, austere, conveying confidence, resolve, order, intrinsically suited to the Revolution? Contemporaries and followers of David believed so. But arguments have been put forward that neo-classicism was a tyrannical and reactionary style, since it was based on reference to the authority of antique art. With the Revolution of 1830 it was the romanticism of painters like Géricault and Delacroix which was predominantly seen as the true expression of the revolutionary spirit. There is no single or simple answer. This complex question will be discussed later in the Romanticism units of the course.

It seems appropriate, in view of the whole Age of Revolutions Course, to discuss the art of two revolutionary periods in France. The first period lasts from 1787 to 1794. The second is the July Monarchy which lasts from 1830 to 1848, though we shall mostly be concerned with the first half of this period. The dominating

artistic force of the first period was Jacques-Louis David (pronounced 'Dah-veed') who in the time became the chief artistic propagandist for the Republic, as much through his civic festivals as by his paintings. Both aspects of his work will concern us here. Two powerful figures emerge with the July Monarchy: Charles Philipon and Honoré Daumier. Unlike David, whose role in the first period was chiefly to uphold and perpetuate the State, that of Philipon and Daumier was to destroy it. These distinctions determine the fundamental character of their art. The works of these three politically-minded artists are those we want particularly to explore.

The July Monarchy is marked by what can well be described as vengeful guerrilla warfare between a small band of caricaturists and the legalistic paraphernalia of the State. It is unique in the history of caricature. The feud between those artists and Louis-Philippe, the king, demonstrates the brilliant effectiveness of art used as a political weapon when in the hands of masters. The issue of censorship of the press as it pertains to art is especially important and will be discussed.

BROADCASTS

Unit 29

TELEVISION

Despite the publication in 1948 of an excellent book on David's civic festivals (David Dowd, *Pageant master of the republic: J.-L. David and the French revolution*) little is known about these startling processions in revolutionary France. In the television broadcast for Unit 29 we will attempt to reconstruct David's festival of the Supreme Being which took place on 8 June 1794.

RADIO

One of the most important things about David's art is that its symbolism, based on antique models, was very readily comprehensible in France. The extent to which 'classical' learning was there engendered and what special meanings it carried for art is the subject of this programme.

Unit 30

TELEVISION

This broadcast will bring to you one of those archetypal villains created first for the theatre, then for the pages of satirical journals, to criticize the French way of life. His name is Robert Macaire, an unscrupulous rogue and living compendium of everything shady and sinister in the society of the day. Daumier executed over 100 lithographs on Macaire, tracing his knavish activities in the days of the July Monarchy.

RADIO

The Revolution of 1848 brought the July Monarchy to an end. It gave rise to an unbridled enthusiasm among Republican-minded artists for a new order of things in which art would play a major social role. This radio programme, called '1848', though somewhat beyond the period intended for the course, serves to round off the chronological scope and subject of the correspondence text.

I would like to thank my colleagues on the Course Team for their many useful observations. I am especially grateful to Clive Emsley, Tim Benton, Derek Rowntree, Arnold Kettle and John Ferguson for their kind help.

Unit 29 JACQUES LOUIS DAVID AND THE FRENCH REVOLUTION

Brutus

1 Look at colour plate I. This painting, by David, is called *Brutus*, though that is not its full title. Study it carefully. Then, in your notebook, try to answer the following three questions:

(a) What overall mood does the picture evoke?

(b) How is that mood conveyed in terms of its compositional elements?

(c) Assuming that you don't know the full title, or the precise meaning of the painting, I wonder how close you can come to describing the story it tells?

DISCUSSION

2 (a) The mood evoked by David's *Brutus* will obviously vary somewhat according to different interpretations. Many of you, I'm sure, will alter your initial response to (a) after answering (b) and (c) yet, I think there must be some measure of agreement as to the mood immediately conveyed by the painting. Certainly, few of us would be struck with it as cheerful, or light-hearted in any way. It has for me rather an autumnal sadness. It is sombre and pensive in a dramatic, almost melodramatic, way, and, above all, evokes a great sense of tragedy. But are these things imparted purely by the more literal elements: the expressions on the faces, the gestures, the bodies being carried in? If that were all the artist could employ to get his message across, the painting would fail. For then it would merely be a description of an event and not a picture in which as many elements as possible were made in some way to reinforce the content.

(b) If you could see that the whole scene is like a stage set, then you are on to a meaningful thing. David and his contemporaries were very much influenced by dramatic productions of antique subjects. The effect Theatre had on the actions of people in those days was, I believe, even more powerful than the cinema exerts on us today. Calculated to inspire revolutionary sentiments and passions, 'the influence of theatrical entertainments on the public mind is too powerful to be neglected . . .' commented a contemporary observer (John Moore, see paras. 29 and 46). David, we know, assiduously frequented the Comédie Française. As in a stage set, the lateral composition and frieze effect of the painting and its shallow volume of space is maintained by the cloth backdrop and even by the arms of the bier (though it is being moved into depth). Action takes place 'off stage'. The limiting of depth is also accomplished in the figure of Brutus with its frontal view of the torso combined with the profile of the legs, the formula known in Egyptian art. This flattening of the composition also occurs in other figures and is sustained in several other ways. Heads, for example, are shown only in profile or full front. Shadows are used to neutralize the background and to swallow up the figures on the left, keeping all attention on the frontal planes. The shadow cast on Brutus has both a compositional and, I think, a symbolic meaning. The device of covering the face of the mourning woman at the right had notable antecedents, and in a way is a clue to the suppressed emotion implicit in the whole scene. Perhaps the hot, burning colours are the only

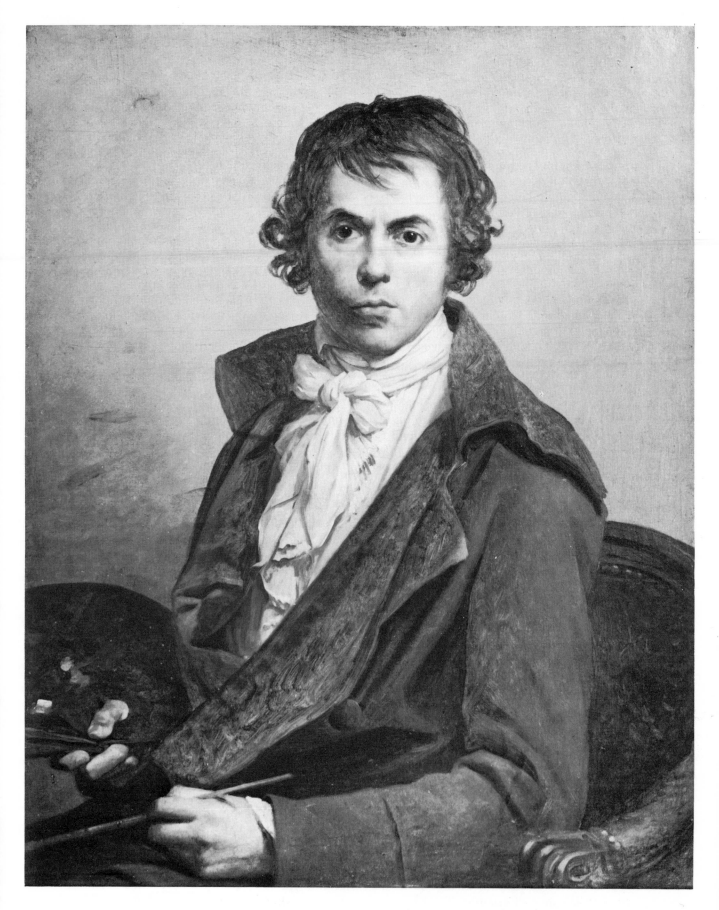

Fig. 1 Jacques Louis David. Self-portrait painted in 1794 while in detention.

elements in the composition which, in the context, overtly express the terrible meaning of the event. It is even suggested, with some relevance, that the unusual composition in disposing figures laterally ('in a line') across the canvas, had behind it, if not a political, an ethical, democratizing motive. David was in his time criticized for this type of composition and for not adhering to the hieratic, pyramidal structure so beloved of other academicians.

(c) The story the painting tells is described in paragraph 5.

3 About six weeks after the storming of the Bastille on 14 July 1789, David submitted his *Brutus* to the Paris Salon. Begun in the previous year, by the time the painting was completed several important acts anticipating the Revolution had already taken place. Louis XVI called a meeting (the first since 1614) of the 'States General'; the 'Third Estate' broke from it, took the famous Oath of the Tennis Court, and formed a Constituent Assembly. After the Bastille was destroyed, the Third Estate decreed the end of the feudal system and instituted a number of reforms. All these, and more, occurred by the time the Salon opened on 25 August 1789. It is hard to believe that an artist who was soon wholeheartedly to throw in his lot with the most radical section of the Revolution, who was to join the Jacobin Club at the beginning of February 1790, and eight months later to form the 'Commune of the Arts', could have been apolitical in his conception of the *Brutus*. Years later David said, though in retrospect, that the *Brutus* had deliberately been conceived as a political statement. That this painting evoked a political response, whatever its author's intentions, there can be little doubt. The painting was, we know, for a brief period withdrawn from the Salon before being shown. The details are obscure, and opinions vary. It is said on one hand that it was suppressed out of political expediency; on the other, that David had neglected to follow the official procedure in registering his canvas for the exhibition. Fearful, probably, that the Salon exhibition would, in the circumstances, be used by revolutionary, and even pro-Royalist, artists as a means to disseminate propaganda, other paintings too were placed under an interdiction. For whatever reason David's painting was withdrawn, an enormous howl of protest was raised and the order prohibiting the *Brutus* had to be rescinded. When, finally, it was shown, a self-appointed group of artists in the uniform of the new National Guard is said to have stood vigil over it, presumably to make sure no further attempts to suppress it would be made.

4 What was in the *Brutus* that made it dangerous propaganda? The full title of David's painting is given as: *J. Brutus First Consul on his return home after condemning his two sons who had joined the Tarquins and conspired against Roman liberty: lictors bring in their bodies for burial.*

5 Here is the story as given in J. Lemprière's *Classical Dictionary* (1908 edition):

Brutus, L. Junius, a son of M. Junius and Tarquinia, second daughter of Tarquin Priscus. The father, with his eldest son, were murdered by Tarquin the Proud, and Lucius, unable to revenge their death, pretended to be insane. The artifice saved his life; he was called *Brutus* for his stupidity, which he, however, soon after showed to be feigned. When Lucretia killed herself, B.C. 509, in consequence of the brutality of Tarquin, Brutus snatched the dagger from the wound, and swore, upon the reeking blade, immortal hatred to the royal family. His example animated the Romans. The Tarquins were proscribed by a decree of the senate, and the royal authority vested in the hands of consuls chosen from patrician families. Brutus, in his consular office, made the people swear they would never again submit to kingly authority; but the first who violated their oath were in his own family. His sons conspired with the Tuscan ambassador to restore the Tarquins; and when discovered they were tried and condemned before their father, who himself attended at their execution. Some time after, in a combat that was

fought between the Romans and Tarquins, Brutus engaged with Aruns, and so fierce was the attack that they pierced one another at the same time. The dead body was brought to Rome, and received as in triumph; a funeral oration was spoken over it, and the Roman matrons showed their grief by mourning a year for the father of the republic.

The fullest account of the event portrayed by David is in Dionysius of Halicarnassus 5, 8.

6 With Brutus, the first Roman Republic was born. It traditionally began in 509 B.C. and lasted for four and a half centuries. In the painting, engulfed by the shadow of a statue personifying Rome, sits the stricken but resolute Consul while the tragic consequences of his act unfold behind him.

7 How well was the story known? All literate French must have grasped, from reading Livy and eighteenth-century writers on antiquity, the full meaning of Brutus's action. What would you say is the possible political message of the painting, now that you know something of the background?

8 Two interpretations might be put on the painting. It could be seen as representing mainly a stoical act of sacrifice. It could also be regarded as primarily a reference to Roman (and French) liberty as a result of the banishment of Tarquin, and an exaltation of the spirit which put national liberty before family ties. Or, the two elements might be taken together as depicting one larger ethical-political idea. Certainly, after the painting was exhibited, whatever David's intentions, a clear-cut anti-royalist meaning was attached to it. Brutus was the personification of the Republican hero. He was soon, as we shall see, to be treated as the object of a devoted cult. In the minds of the French it must have been patently clear that the story of Brutus and Tarquin was an allusion to their own revolutionary situation. For many, even the bland Louis XVI was the reincarnation of the evil Tarquin, 'the last king of Rome'. Tarquin's extravagance and its disastrous effects on the royal treasury, his contempt for the decisions of his Senate or for public opinion, are analogies all too fitting to the situation in France before 1789. Tarquin's final banishment and the establishment of a Roman Republic were yet to be re-enacted in France.

Could the *Brutus*, in 1789, have been hailed as a 'Republican' painting?

The answer is no, not during the period of Constitutional Monarchy. Not much talk of a Republic occurred before the early part of 1792.

9 David's *Brutus* had a powerful impact on the imagination of the French people. It was extremely well-known, even if little seen outside Paris. David and his painting were associated with Voltaire's play, *Brutus* (written in 1730). This was revived on 17 November 1790 and performed as a challenge to the many counter-revolutionary plays supported by royalist interests. All these plays were loaded with political inferences and audiences often demonstrated loudly for or against them during performances. The staging of the *Brutus* was a signal for the royalists to voice their disapproval. The 'patriots' succeeded in ejecting them from the theatre (if not on the first night, on the second). To ram the message home, a Roman bust of Brutus had been placed on the stage by David – a constant reminder of its meaning. As the performances ended, a living tableau of David's powerful painting was re-enacted on the stage, an indication both of the realism of the work which could be reproduced, *live*, and of its theatrical character. So, a year after the Brutus painting was first exhibited, it had taken on an even more explicit anti-royalist meaning. David's extremism may be gauged by the words of the miniature painter J. Guérin, a royalist,

who was shocked to see on a wall in David's studio a sketch showing the king at the guillotine, his head severed, with the inscription, 'The head of the tyrant will soon fall like this'.

10 David's *Brutus* has always posed a problem for historians. The meaning of the picture is often held to be ambiguous. What did the artist really intend to say? Did he himself give it a different meaning after the catastrophic July uprising? Soon after the storming of the Bastille the king took an oath of loyalty to the new Constitution. There was no serious question then of ridding France of its monarch. Furthermore, David had been favoured by royalty. Encouraged and protected by the king's adviser on art, Count Angiviller, recipient of a studio in the Louvre, successful exhibitor in Rome, where cardinals and other notables came to admire his paintings, full academician since 1783, David's position in the artistic firmament was waxing brilliant. How, then, could he be capable of such an invidious act towards his benefactors?

11 My view is that despite these things, David meant exactly what the painting purports to say. Two reasons may be given why many art historians hesitate to admit of this possibility. One, the general reluctance to see a great painter as a political animal and two, a misconception or ignorance of what happened in France in the years *before* the destruction of the Bastille.

12 As to the first, many if not most writers in discussing David's work of this period, soft-pedal his preoccupation with politics. There is a tendency to see his involvement with politics and his involvement with art as mutually exclusive, not as mutually reinforcing. David's political activities are also seen as an aberration excusable in so great an artist, or primarily as a means of securing the freedom of artists from the tyranny of the Academy. It was, after all, as early as September 1789, during the Salon exhibition, that David published his 'Artists' Vow', a statement of opposition to the artistic establishment supported by the king. In such cases, an undue amount of emphasis is put on the iconographical or aesthetic character of his work, without seeing both those elements as means towards a predominantly political end. Conversely, David has been praised in retrospect as the archetypal artist-politician, the progenitor of a modern political consciousness in the arts. Sometimes, too, the exaggerated view is taken that David's art was great *because* of his political convictions, with insufficient attention paid to his brilliant, artistic vision and his abilities as a draftsman and painter.

13 The nature of David's political involvement was disputed even by his own contemporaries. Certain paintings of his like the *Belisarius* (1781) and *The Oath of the Horatii* (1784) (both illustrated in Friedlaender, *David to Delacroix*), despite the fact that they were executed years before David's political allegiances were crystallized, were seen both as revolutionary and as upholding the old régime. Even the Left have not always been consistent in their interpretations of David's intentions. The Russian Menshevik,[1] Georgiy Plekhanov, writing in 1910, held him up as a true revolutionary artist.

14 He praised the *Brutus*. It gave expression, he said, to the deepest, most essential need of France at the time, that of being a conscious, social entity. Russians who find themselves in Paris are duty bound to go to the Louvre and pay to this painting their respects. Plekhanov stressed the importance in David's painting, not only of subject matter, but the style and execution too. Its 'severe

1 The Mensheviks were a more moderate element in the Social Democratic Party of Russia and antagonists of the Bolsheviks.

simplicity', the 'reason' implicit in its use of antique prototypes,[1] was not only a stylistic departure from the 'affectation and sugariness' of the old school, but consistent with the character and aspirations of the revolution. Despite such eulogies, David has been criticized by at least one extreme Left historian as a 'cynical bourgeois betrayer of the proletariat' (Daniel Guérin cited by Hugh Honour, *Neo-classicism* 1968).

15 There was no lack of denunciation from many quarters for this 'Raphael of the Sans-Culottes' as David has in derision been called. One of the most vehement, perhaps, came from Thomas Carlyle in 1837. 'Gross David', he called him, 'with the swoln cheek' (David suffered from a tumour on his left cheek),

> has long painted, with genius in a state of convulsion; and will now legislate. The swoln cheek, choking his words in the birth, totally disqualifies him as an orator; but his pencil, his head, his gross hot heart, with genius in a state of convulsion, will be there. A man bodily and mentally swoln-cheeked . . . so let him play his part.

16 The second reason for the reluctance to admit that the *Brutus* was deliberately anti-royalist, is, I believe, that of the ignorance of the history of events immediately preceding the storming of the Bastille, from which date the Revolution is usually considered to have begun. 'Traditionally the French Revolution has been treated as one single, protracted episode, which opened with the meeting of the States General at Versailles in May, 1789, or with the fall of the Bastille in July.' So writes George Rudé in his book, *The Crowd in the French Revolution* (1959), and he continues, saying that in recent years only have historians accepted the proposition that the first important step in the Revolution occurred at least two years earlier, in May 1787, when the king dismissed his aristocrats and their Assembly of Notables.

17 Rudé traces in fascinating detail the surprising chain-reaction of events in those two years which formed, as he says, the prelude to revolution.

> The disorders continued for a week, during which bonfires were lit in the square before the Palais, anti-royalist tracts were distributed . . . and the Comtesse de Polignac, the governess of the royal children, [was] burned in effigy. . . . In the following months . . . the crisis deepened – not least because the return to Turgot's free-trade measures had led to a sharp rise in the price of grain . . . the presence of troops prevented an angry crowd from burning down the Law Courts. A new phase of violence followed – at first mainly in the provinces: there were mass riots in Grenoble and Rennes in June [1788]; in Dauphiné nobility and Third Estate joined forces against the Crown in July. Early that month, angry placards threatening the king with mass revolt appeared in the Cité [in Paris]: 'Tremblez, Tyrans, Votre règne va finir'. . . . A new factor, however, was to extend these disturbances far beyond the scope and limits of the previous year. On 17 August the price of the 4-lb loaf, after long remaining at 9 *sous*, rose to 9½ *sous*, on the 20th to 10 *sous*, on 2 September to 10½ *sous* and on 7 September to 11 *sous*.

18 The riots intensified, and violence increased as the troops began to fire at the crowds. By the beginning of 1789, when David was working on his *Brutus*, every class in society was in revolt against the monarchy, even sections of the nobility (see Unit 3, 3.2). At the time of painting *Brutus*, David is known to have been associated with the anti-royalist faction, a group of liberal nobles, artists and writers led by the Duke of Orléans who later, in support of the

1 Louis Hautecoeur (*Louis David*, Paris 1954) describes the following sources: the head of Brutus is from an antique bust. The pose combines those of two antique sculptures of philosophers. The chair, drapery and the general disposition, from a statue in the Villa Negroni. The gesture of his right arm is inspired by sculptures of philosophers in Roman collections. The wife of Brutus and her daughters recall the Niobe group in Florence. The men carrying the corpses come from the Arch of Titus in Rome. The furniture is modelled on drawings made from the antique. The decoration of the room represents an atrium of a house with Doric columns.

Revolution, took the name, Philippe Egalité. An expression of the degree of hostility towards royalty is indicated in a written statement made in 1788 which held that not only should the nobles not be masters, they hardly have the right to be citizens (quoted in Albert Sorel: *Europe and the French Revolution*, 1885).

19 It is with these things in mind that I suggest that David's *Brutus* was a deliberate and calculated attempt to discredit the king. Had David's intention been to represent Roman virtue rather than an act brought about by a royal tyrant, could he have been so obtuse as not to see that the *Brutus* also conveyed this latter meaning? Would he have risked royal patronage by making such an obvious blunder? Would he have allowed it to be seen in the Salon where its full meaning could hardly have been lost on the populace – whatever his intention – and where, in fact, the analogy with Louis XVI was unequivocally made?

20 Now, what is most paradoxical here, and difficult to account for is that Louis XVI purchased the *Brutus* for 6,000 livres despite the message it ostensibly conveyed. Assuming that my suggestion that the painting's intention was political is right, what reasons would you give for the rather puzzling move of the king? Admittedly, this is a difficult question as the only evidence one can bring to bear is circumstantial. Yet one might offer explanations. How many can you think of?

DISCUSSION

21 The picture had certainly not been commissioned by the king. He wanted from David a *Coriolanus*, a theme of clemency symbolically much more palatable to the Throne. A royal inventory describes the painting as representing Brutus having returned home after condemning to death his two sons who had conspired against Roman Liberty. But it says 'Roman Liberty', and nothing about any collusion with the exiled Tarquins. The king through his advisers, Angiviller possibly, may have found it expedient to purchase the *Brutus* to soften any criticism the painting evoked and to demonstrate that though he may not wholeheartedly support the Revolution, he at least could ride with it. He may genuinely have liked the picture despite its message. Furthermore, paintings with antique themes were often ambiguous in meaning and could be (and have been) interpreted in more than one way. Seeing in David an irrepressible power in the world of art, and a potential danger to the throne, the king may have hoped to win his friendship if not his loyalty. If Louis hadn't purchased the *Brutus* it may well have hung in a public place after being shown in the Salon. Better then, to keep it at home. You may have suggested similar reasons. Or, if the thesis that the painting carried a political message is unacceptable, little explanation would be necessary in view of the traditional predilection of royalty for such antique themes.

Martyrs of the Revolution

22 The most lavish obsequies, organized by David, were held in 1793 for three men who were martyred for the Revolution. One might even say that those funerals were works of art. They were brilliantly and dramatically conceived, and all

the resources of elaborate theatrical productions were used to guarantee their success. Whatever heartfelt regrets there were for the loss of those men, the funerals were convenient vehicles for Jacobin propaganda.

23 Two of the dead men were victims of assassination, the other, possibly, of poisoning. Each in his turn was murdered in retaliation for deeds committed out of a strong sense of duty.

24 The first victim was Michel Lepelletier de Saint-Fargeau. He was a highly respected deputy said to have little propensity for violence. Yet he was cut down on 20 January by one of the king's old bodyguard for his part in voting for the monarch's execution. In the eyes of many Frenchmen, Lepelletier was innocent of any crime in the performance of his duties and out of fear that such acts of vengeance might be repeated, the Jacobin Club took the initiative and turned to the people declaring the act a blow against them and their liberty.

25 Held on a cold January day, the funeral was a grisly affair. Like that of Caesar, whose naked body showing the fatal stab wounds was displayed to the populace of Rome, Lepelletier's corpse was exposed in the Place Vendôme before it was taken in procession to its place of honour in the Panthéon.

26 The second victim, presumed to be poisoned, in that vengeful year was a member of the Paris Commune: Lazowski, who had distinguished himself in the two main sans-culottes attacks on the Tuileries Palace in the previous year (20 June and 10 August 1792). He was hated by the Girondins for his part in the riots against them in March. Robespierre himself presented a eulogy to the martyr and as with the funeral of Lepelletier this one was just as elaborate, and solemn, and served equally well to rouse the people against the enemies of the Revolution.

27 David Dowd, basing himself on a large number of contemporary documents, describes the event:

> on April 28th, 1793, the popular societies and the Paris sections turned out in imposing strength, Gossec provided heart-rending music, and David created a splendid funeral cortège 'worthy of an ardent friend of the Revolution'. The procession with its red flag, tocsin bell, pikes, and cannon breathed the spirit of insurrection while other symbols were calculated to rouse popular fury against Lazowski's enemies – the Girondins. The hero's remains were solemnly borne in triumph through the streets to the Hôtel de Ville on a tri-coloured bier. Finally they were laid to rest at the foot of the Tree of Fraternity on the Place du Carrousel – where he had given the signal for the storming of the Tuileries on August 10. As far as can be determined from contemporary accounts, this festival was as successful as that of Le Peletier.
>
> (*Pageant master of the republic: J.-L. David and the French revolution*, 1948.)

28 The third martyr of the Revolution, and by far the most notorious, was the journalist, Jean-Paul Marat. Of the three, his name is best known to us, largely owing to David's famous painting of him (plate II) which will soon be discussed. Marat too, was a devoted Jacobin and enemy of the Girondins. His death on the 13 July was macabre. He was stabbed in his bath by Charlotte Corday, a young royalist sympathizer from Caen who associated with the Girondins.[1]

29 Of all the Jacobins of the Revolution, Marat had a reputation for being the most bloodthirsty. He was, in addition to his duties as a deputy, a journalist, editing the paper *The Friend of the People* on the front page of which was carried the daily motto, borrowed from Rousseau, and by Rousseau from the Roman satirist Juvenal, 'Stake your life on the truth'. Marat was genuinely sympathetic towards

1 Her favourite reading was Plutarch (see para. 41) and, ironically, the Biblical story of Judith.

the poor, and an unwavering patriot. He had a large and devoted following. He was nevertheless described in the most uncomplimentary terms by John Moore, a Scottish physician who lived in Paris from August to December, 1792. Moore's opinions were shared by others. A 'Pretended patriot' Marat was called, 'A *real* incendiary'; 'This Marat is said to love carnage like a vulture [wrote Moore] and to delight in human sacrifices like Moloch, God of the Ammonites'. Moore describes Marat's appearance:

> Marat is a little man, of a cadaverous complexion, and a countenance exceedingly expressive of his disposition: to a painter of massacres Marat's head would be inestimable. Such heads are rare in this country, yet they are sometimes to be met with at the Old Bailey.

30 Moore gives us an eye-witness account of Marat's performance as an orator:

> When Marat is in the tribune, he holds his head as high as he can, and endeavours to assume an air of dignity – He can make nothing of that; but amidst all the exclamations and signs of hatred and disgust which I have seen manifested against him, the look of self approbation which he wears is wonderful – so far from ever having the appearance of fear, or of deference, he seems to me always to contemplate the Assembly from the tribune, either with the eyes of menace, or contempt. He speaks in a hollow croaking voice, with affected solemnity, which in such a diminutive figure would often produce laughter, were it not suppressed by horror at the character and sentiments of the man.

31 More even than the deaths of Lepelletier or Lazowski, Marat's assassination brought forth the most furious condemnations and great spontaneous demonstrations. For the third time that year, David was asked to organize a funeral. The day before the assassination, Marat had been visited by a deputation from the Jacobin Club. They found him, as had Charlotte Corday, in his bath. He took frequent hot baths to obtain relief from a skin ailment. There, it is said, he was writing about the people's salvation. It was decided that the corpse would be shown to the populace exactly that way, in his bath, writing, before moving it off for burial. It was. Just as it had been found, in the bath-tub, with the writing implements, and with the terrible wound in the chest. But it was July, and putrefaction had begun. Before the burial procession, the body was wrapped in wet cloths, and that night, with drums rolling, the huge silent crowds, lighting the way with torches, moved through Paris to Marat's final resting place in the Panthéon.

32 At the request of the Convention, David executed two paintings to commemorate the deaths of Lepelletier and Marat. The first was presented to the Convention on 29 March 1793; the second on 14 November. Of the Lepelletier, nothing now remains but a drawing (and one battered print) made from the posthumous portrait (Fig. 2).

The original is believed to have been destroyed after the Bourbon Restoration in 1815, possibly by Lepelletier's own daughter, said to have later become an ardent royalist. The Marat painting, of which prints were also made, is now in the collection of the Museum of Fine Arts in Brussels (plate II).

33 The size of the *Marat Assassinated* is 1.65 × 1.28 metres (about 65 × 50 inches). Look carefully at the two works shown. Would you like to guess the size of the original Lepelletier painting? Do you have any comments to make on where and how they might have been hung?

Fig. 2 David. Lepelletier de Saint-Fargeau Assassinated. *1793.*

DISCUSSION

34 Remember that both paintings were commissioned by the Convention, and so it would be feasible that they would be hung in the Convention Hall. That, in fact, is what happened. Furthermore, you might have guessed from the similarity of the composition (in reverse) that the Marat was conceived as a 'companion piece' to the Lepelletier. If so, it is most likely that it was painted approximately the same size. They hung on either side of the President's chair. Both paintings carry a verbal message. 'I vote for the death of the tyrant' was inscribed on the paper in the Lepelletier painting. The sheet Marat holds in his hand is Charlotte Corday's letter to him with her words of retribution, claiming the right to murder him. The letter he was writing when the evil deed was done shows him to be a real friend of the people. 'Give the money [it says] to that mother of 5 children whose husband was killed in the defence of the country.'

35 There were, in fact, other paintings made of precisely the same subject. Two replicas of the *Marat* to be executed under David's supervision, were ordered by the Convention in May 1794. One of them for many years was believed to be the original.

36 David at first proposed to the Convention that a competition be held for a statue of Lepelletier just as he had been shown to the people in the Place Vendôme. That was in keeping with antiquity when memorials of such events were so retained. But there seems to be no indication that it was carried out; David's painting became the memorial and was composed probably as the corpse had been displayed. A report was given in the Convention (10 May 1794) in the name of the Committee of Public Instruction, saying that the artists and workers of the famous Gobelins factory wanted to copy David's paintings of Lepelletier and Marat in tapestry. Nothing, it appears, came of it as the Mountain (the Montagnards) soon came tumbling down with 9 Thermidor (27 July). The martyrdoms of Marat and Lepelletier were no less significant to the revolutionary peasant bands of Piedmont in Italy where, ironically, in 1799, they carried portraits of the two Frenchmen in demanding from the French invaders a united Italian Republic.

37 On presenting each painting to the Convention, David, deputy from Paris, pronounced a eulogy on the first occasion on Lepelletier, then, later, on Marat. You may wonder what David's oratory was like considering the incapacity Thomas Carlyle spoke of (see paragraph 15). David also had a stutter. A collection of anecdotes about the founders of the French Republic, published in 1797, describes the great difficulty he had in speaking:

> Nature, or rather disease, has incapacitated David from being an orator. A frightful tumified cheek has not only distorted his features to a great degree, but, at the same time, disqualified the organs of speech from uttering ten words in the same tone of voice; so that a grave subject, in his mouth, notwithstanding the sensibility of the man, loses its dignity: and at best he is only able to give a silent vote.

In Appendix I (page 32) you will find two translations of David's discourses from the original documents of the National Convention. The first, on Lepelletier, was made on 9 Germinal, year II (29 March 1793); the second, on Marat, 24 Brumaire (14 November). They will give you a good idea of the extravagant rhetoric used in the Convention in that heady time. You must keep in mind that oratory always sounds peculiar when removed from its context, especially when that context is war and revolution.

38 David executed (but did not complete) one more painting dedicated to yet another martyr: Joseph Barra, a thirteen year old drummer boy from the Vendée. Elaborate funerals for Barra, and another youthful hero from the

south, Agricole Viala, were asked for in the Convention by Robespierre at the end of December 1793, but were never held (read David's plan for the immortalization of Barra and Viala in your Sources and Documents, *Neoclassicism and Romanticism*, pp. 134–6). But what could not be accomplished in the streets took place in the theatre. From 20 Germinal (9 April 1794) till at least 30 Prairial (18 June), the apotheosis of Barra was enacted almost daily at the Théâtre de la rue Feydeau, and sometimes at the Théâtre de l'Opéra-Comique National. From 16 June, and for some time following, a dramatization was given on the life of Viala at the latter theatre (see the translation of the *Chant du Départ* eulogizing these two heroes in the Reader for the course, D6).

The Power of the Past

39 Not only did the yearning for a revival of the heroic days of antiquity create a sense of common destiny, but the history and mythology of the ancients provided the French with a usable symbolic language to describe their thoughts, their aspirations and their actions. When the king was insulted, the language of vilification drew on the past and he was called Tarquin or Caligula. The concept of liberty was understood by the people in the same way the king understood it. It was called 'Roman Liberty', and it recognized no higher authority than itself. Sorel writes (*op. cit.* paragraph 18) that this conception, restored by Rousseau,

> adapted itself wonderfully to the classical formulas long accredited in France by the monarchy. It belonged to the habits and traditions of the French. The study of classical literature had propagated this spirit.
>
> 'It kept their self-respect alive in their hearts and often ensured the predominance of the thirst for glory over their other passions. It created the vigorous, proud and audacious spirits . . . who made the French Revolution at once an object of admiration and terror to the generations which followed.'
>
> (Alexis de Tocqueville: *L'Ancien Régime.*)

40 The well-known words of Mme. Roland support this view. Reading in her youth a popular translation of Plutarch's *Lives* had, she said later, a profound effect upon her: 'From that moment I date the impressions and ideas which were unconsciously to make me a Republican'. Instead of her prayer book, she carried Plutarch to church, and profoundly regretted not having been born a Greek or Roman.

41 In a remarkable study by Harold Parker called *The Cult of Antiquity and the French Revolution* (1937) several aspects of the influence of antiquity on French life and manners during the revolutionary period are explored. It is clear from what Parker writes that the adulation of antiquity, for Republican Rome especially, was firmly implanted in the schools. The actual range of authors from the past, and of eighteenth-century histories of Greece and Rome, was not very extensive, and quite often, a large degree of uniformity existed in the subjects studied. This was particularly true of Paris where, for example, several schools were geared to the same examination system, and consequently to the same authors and texts. Virgil's *Aeneid*, Horace's *Ars Poetica*, Ovid's *Metamorphoses* and Cicero's *Orations* were basic fare in many, perhaps most, schools. And while these apparently formed the core of classical learning among the educated French, added to them later were other works by the same writers and also by Livy, Tacitus and Plutarch (a Greek living after Rome had ceased to be a Republic), to name the most important. It is clear, Parker says, from

the printed parliamentary debates, that the citations were predominantly from Roman, rather than Greek, sources, with perhaps the exception of Plutarch. That was consistent with what had been studied in school. Even Plato was cited only by a few of the revolutionaries.

42 Most of the writers who were studied, says Parker, from Cicero to Plutarch, lived

> When the greatest days of the *Roman Republic* belonged to the past. All of them lived in a present which they . . . found unsatisfactory. All of them . . . tended to contrast their present with this republican past, to endow the latter with those virtues that were the converse of the vices they saw thriving about them, with the result that the more darkly they portrayed their present, the more brightly they painted their past.

43 Furthermore, Republican Rome as described in glowing terms by Cicero, Plutarch and Livy was not all sweetness and light, nor totally stable. It was the place where the liberty of the people, freedom from slavery, could only be gained by the destruction of despots and usurpers.

44 It is hard for us, considering our own educational system, to grasp the impact antiquity had on the life-style of the French, and on the very way the Revolution was carried out. There is in our education no common denominator of such power and dimension, no great myth. Its effects were well enough understood by teachers and the writers of texts, for often, before the Revolution, they played down the more explosive acts of Roman society, preferring to amplify the private virtues: industry, honesty, simplicity, courage. Not all educators appreciated the image of antiquity; undoubtedly they formed a minority.

45 The demonstration in physical terms of the adulation for antiquity is readily seen in all the arts and particularly in the festivals designed by David. But also, the influence of the past is apparent in the records of speeches given in the revolutionary assemblies. Pick up any journal reporting them and the allusions to Rome jump out at you. And what could be more inspiring than to deliver one's oration from the tribune of the Convention, flanked by busts of Brutus and Lepelletier? Parker worked through a large number of those documents and made a chart which showed that Cicero, Horace, Plutarch and Tacitus, in that order, were among the most frequently cited. Eighteenth-century writers on antiquity like Montesquieu and Rollin, along with Rousseau and Voltaire played their parts too in the oratory of the revolutionary tribunals.

46 In the journals of John Moore, the Scottish physician already mentioned, several examples are given of references to antiquity in the speeches made in the Convention. The Austrian monarch was scathingly referred to as Caligula. The examples of Scaevola, Pelopidas, Timoleon, Brutus, were cited when discussing the recruitment of 1,200 extraordinary volunteers whose job it would be to assassinate the generals and princes who commanded the invading armies, and they were compared with a sacred band of Greeks who had performed a similar function. When debating the fate of the king, a lesson was to be drawn by the statement that 'Charles I [of England] had successors, the Tarquins had none'. On one occasion Danton was called to order. 'For what?', he cried, 'In the Senate of Rome Brutus and Cato boldly spoke out those plain truths which we from the pusillanimity of our manners evade as personalities; for my part I am resolved to accuse, without circumlocution, every person whose conduct I think is suspicious.' References to antiquity, then, in neo-classical art were absolutely in tune with French society and carried with them a literary power which transcended even the most brilliantly executed canvas.

47 Before the Revolution, the nobility itself engendered the belief that art, especially neo-classical art, was a didactic vehicle well suited to help maintain the status quo of the throne.

48 The importance of men like Diderot and the antiquarians Count Caylus and La Font de Saint-Yenne in stimulating interest for the ancients among artists and others will be discussed in the radio programme which accompanies this unit.

49 In his own education, David was steeped in antiquity. He became an avid reader of Plutarch, of Tacitus and Livy. But much of his education was directed by books written in the eighteenth century *interpreting* Greece and Rome. If his education in the classics was somewhat removed from the source, that was corrected when he went to Rome in 1775 after finishing his schooling, and again in 1784.

50 It was in Rome that David filled his sketchbooks with studies, not only of contemporary life and from the works of Renaissance masters, but also from the many examples of ancient art extant in Italy: the sculpture of the Trajan column, the arch of Titus, the arch of Constantine, Greek and Roman artifacts of all kind. These studies provided him years later with raw material, not only for his paintings, as for example in the *Brutus*, but for all the apparatus so effectively used in his revolutionary festivals.

Revolutionary place names

51 The Revolution was all-embracing. It did not stop short at politics. An attempt was made to destroy every vestige of the *ancien régime*. Districts were renamed. Streets and squares were called after revolutionary heroes. The names of towns, even, changed. The sans-culottes of Saint-Maximin, for example, gave to the place the new name of Marathon, appropriately conveying both the famous site of the battle where the free Athenians defeated the troops of the Persian monarch, and the revered memory of the famous revolutionary martyr. Montfort-l'Amaury became Montfort-le-Brutus; Saint-Pierre-le-Moutier, Brutus-le-Magnanime. Another town was called just plain Brutus. In Paris, especially, streets could now be found with names like rue de Brutus, rue de Cato, Scaevola, Franklin and also Liberté, Egalité, République, and even rue de Guillaume (William) Tell, another hero in the Republican panthéon.

The Republican Calendar

52 As a deliberate affront to the Church, the Gregorian calendar itself was altered by decrees of 5 October and 24 November 1793, and the Republican year II began on 22 September 1793. The months now start in autumn with Vendémiaire (September–October), then Brumaire (October–November) and Frimaire (November–December), etc.,[1] and their names, marking great revolutionary deeds, ring in our ears when reading the history of the Revolution:

1 The meanings, roughly translated, are the Vintage month, the Foggy month, the Frosty month; then three winter months, Nivôse, Pluviôse, Ventôse (Snowy, Rainy, Windy); the spring months, Germinal, Floréal, Prairial (Budding, Flowering, 'Meadowing'); the months of summer, Messidor, Thermidor, Fructidor (Reaping, Warming, Fruiting).

Germinal, Prairial, Thermidor. Even the odd five days at the end of the year from September 17–21, plus the new leap-year day, were designated in the Republican calendar as 'jours sans-culottides'. The names of days also change, and often, in the headings of journals, the revolutionary days and dates are given with those of the 'old style' (Gregorian) calendar following in brackets. Thus, in the *Moniteur Universel* (the official equivalent to today's *Hansard* or *Congressional Record*), the week is made up of ten days starting with Primidi, followed by Duodi, Tridi, Quartidi, Quintidi, Sextidi, Septidi, Octidi, Nonidi and finally, Décadi. Primidi, 1st of Germinal in year II, for example, is Friday, 21 March 1794. The following Primidi, 11th of Germinal, falls on an old Monday. Primidi comes again on the 21st, and then again on the first of the next month, Floréal. It was all neat and clean. Thirty days to each month, twelve months, and the remainder, as stated, dedicated to the sans-culottes. Like the conversion to decimal currency, it's easy once you know how.

Names

53 The changes were more extensive than the re-designations of street or towns or the new calendar. Personal names too, were altered or new ones given, not only in adulation of antiquity, but also as part of a move towards dechristianization. In Paris, there was a great propensity for giving personal names (we can hardly call them Christian names) after Republican heroes past and present. Brutus was most popular. One unreservedly patriotic name on the records cited by Parker (*op. cit.* paragraph 41) was Brutus Marat Lepelletier; another, Solon Brutus Weber. The name of Brutus-Marat, taken by one L. Lefaucheux, age 52, did not absolve him from appearing on a list of revolutionary criminals on 18 Floréal, 1794.

54 The brilliant revolutionary and utopian 'communist', Babeuf, changed all three of his Christian names, François-Noël Toussaint Nicaisse to Camillus Caius Gracchus, taking the men of Rome as his new patron saints. To eradicate all traces of royalism, aristocracy and fanaticism, he wrote, Republican names had been given to districts, cities, streets, to everything which bore the stamp of 'these three types of tyranny'.

Costume

55 One can hardly expect such changes to occur without their counterparts in fashion. The Robespierrists' 'Republic of Virtue' had, of course, to *look* virtuous, and David was commissioned to create new and appropriate costumes. Drawing partly on the material recorded in his Roman notebooks, and partly on his imagination, David designed an elaborate range of costumes in keeping with the new revolutionary society. One of them is vividly described by John Moore:

> David, the celebrated painter, who is a Member of the Convention and a zealous Republican, has sketched some designs for a republican dress, which he seems eager to have introduced; it resembles the old Spanish dress, consisting of a jacket with tight trousers, a coat without sleeves above the jacket, a short cloak, which may either hang loose from the left shoulder or be drawn over both: a belt to which two pistols and a sword may be attached, a round hat and feather, are also part of this dress, according to the sketches of David; in which full as much attention is paid to picturesque effect as to conveniency. This artist is using all his influence, I understand, to engage his friends to adopt it, and is in hopes that the Municipality of Paris will appear in it at a public feast,

or rejoicing, which is expected soon. . . . Part of this dress is already adopted by many; but I have seen one person in public completely equipped with the whole; and as he had managed it, his appearance was rather fanatical. His jacket and trousers were blue; his coat, through which the blue sleeves appeared, was white with a scarlet cape; his round hat was amply supplied with plumage; he had two pistols stuck in his belt, and a very formidable sabre at his side: he is a tall man, and of a very warlike figure; I took him for a Major of Dragoons at least: on enquiry I find he is a miniature painter.

56 Though the actual neo-classical style of costume reaches its plenitude during the First Empire (after the turn of the century when David was painter to Napoleon), its fanciful prototypes may be found in the ceremonies and festivals of the early 1790s. The costume shown in this sketch by David (Fig. 3) was meant for dignitaries, though there were others too for ordinary citizens. David executed eleven drawings of such costumes. As Moore suggests clothing like this was mostly worn on special occasions. Zealous deputies like J. B. Milhaud, the terror of Perpignan (see paragraph 95), may well have availed himself of every opportunity to wear the colours, which are shown in this painting made probably by David's students (plate III). This one, of the deputy J. J. Belley (Fig. 4) is by the painter Girodet, a favourite pupil of David.

The tri-coloured cockade, as sported here by Milhaud, is thought to have been designed by the aristocratic general, Lafayette, in the early days of the Revolution, being made up of the colours of Paris (blue and red) and, ironically, the white, of the Bourbon Monarchy. It was officially established that costumes displaying the national colours would be worn at all festivals. A law of 4 April 1793 made standard the *chapeau rond* (a kind of short, top hat with a rounded crown. See plate III), and three coloured feathers with the red one set highest. Added to this later was a tri-coloured waistband, and for Commissioners of the Convention, sabres. Personal choice was allowed for the rest of the costume.

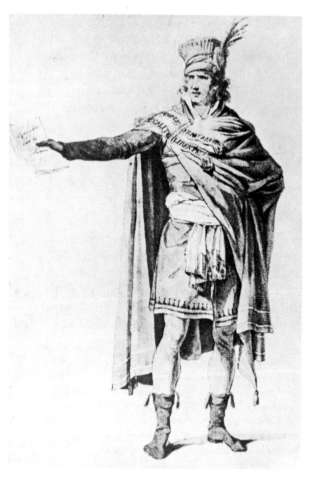

Fig. 3 Jacques Louis David. Drawing for a Republican costume.

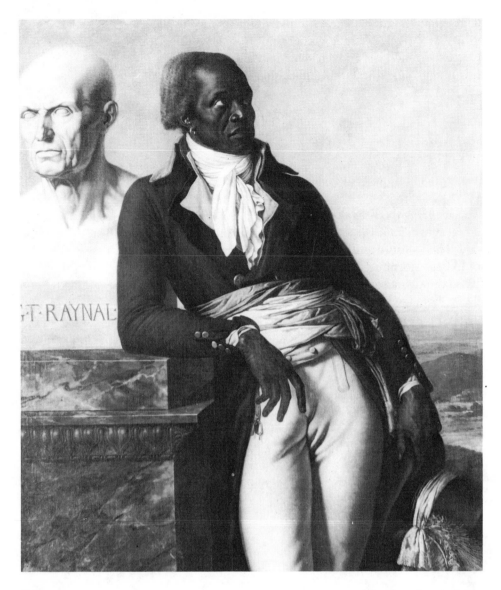

HT·RAYNAL

Fig. 4 Girodet. J. J. Belley,
Deputy from St-Domingo.
1794.

57 All the archaeological elements from antiquity in David's *Brutus*: the clothing,
the furniture, the interior décor, had a great impact on the fashion of the day.
David may also have helped to generate interest in the Phrygian cap, symbol of
Liberty in antiquity. It was first used in his painting, *Paris and Helen*, executed
in 1788. By 1790 it was adopted as the '*bonnet rouge*'. By 1792 it had taken on the
dimensions of a popular fad; David himself wore one.

58 How would you explain the fact that David, an artist of great stature, did not
consider it beneath his dignity to produce costume designs, and indeed, designs
for musical instruments and for the plethora of artful paraphernalia that went
with the civic festivals?

59 Mainly, in my opinion, because the idea of a hierarchy of arts, no less than a
hierarchy of artists, was antithetical to the Revolution and all arts could be seen
to be serving one greater, unifying purpose. Consistently, David was also
instrumental in bringing down the academic art establishment in France (read
'Jacques Louis David and The Suppression of the Academy' in your Sources
and Documents anthology, Eitner, pp. 115–8).

21

60 Even the alphabetical designations used to teach children gave way to a set
of words significant to the Revolution. Nothing was exempt from revolutionary
zeal. The names and types of foods were given over to the cause. 'Cockade
soup' is spoken of, consisting of red, white and blue cabbage leaves.

Patriotic Pottery

61 A substantial industry arose during the French Revolution in decorating pottery
with patriotic motifs. These motifs fall into several categories. Some of them are
the obvious ones: Liberty, The Constitution and The Nation. High-water marks
in revolutionary history like the storming of the Bastille, the first States-General
and the Oath of Loyalty to the Constitution taken by the priests, were recorded
in ceramic form. Similarly, homage was paid to the heroes of the Revolution
('Mirabeau died for liberty') and precursors. Animals, the cock and the cat, as
examples, both symbols of the Republic, are often used to the same ends – the

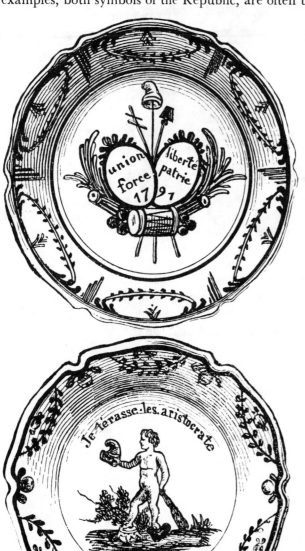

*Fig. 5 Engraving of
Revolutionary pottery.*

*Fig. 6 Engraving of
Revolutionary pottery. Notice
the antique reference in the
infant Hercules.*

22

cat traditionally associated with independence and liberty. The Phrygian Bonnet, the Pike, and Trees of Liberty were frequently employed, as of course were military subjects marking, especially after Thermidor and the downfall of Robespierre, the many French victories.

62 We must not minimize the effectiveness of such popular art in helping to perpetuate the ideals of the Revolution. Most ceramic pieces carried, along with the picture, some verbal message: 'Defenders of the Country'; 'To the Mountain'; 'Long Live the Rights of Man'; 'Vive le Roi' and 'La Loi et le Roi' (before he fell); 'Liberty or Death' and, of course, just plain 'Liberty', 'Equality', 'Fraternity', 'Concord', 'Peace', and 'Indivisibility'. The Sèvres porcelain works were commissioned to produce reproductions for general distribution of the bust of Brutus displayed in the Convention Hall.

63 The lessons of the Revolution were conveyed in several kinds of artefacts. Sometimes they appeared with a chilling insensitivity. In 1794 jewellers in Paris were selling earrings in the form of the guillotine. The guillotine design seems to have been a popular one. Buttons and snuff-boxes, and several other objects were decorated with that cruel instrument of retribution. Souvenir shops, not unlike the ones we know today, stocked crockery decorated with representations of the guillotine. One writer wryly commented in 1864: 'What an appetite those people must have had, to eat off those plates!'

Monuments to the Revolution

64 David envisioned vast changes in the appearance and in the very structure of Paris. In 1792, immediately after the fall of the Bourbon monarchy, the new National Convention decreed that all statues belonging to the old régime were to be removed and destroyed – melted down for cannon (the Prussians had just captured Verdun) or for new sculptures. Among the sculptures demolished were bronzes of Louis XIII in the Place Royale, of Louis XIV in the Place Vendôme and Place des Victoires, and the equestrian statue of Louis XV since 1763 in the Place Louis XV, already called the Place de la Révolution (now the Place de la Concorde). Here, on the old plinth, was put a statue of Liberty near which was soon to stand the busiest guillotine in France. It was the same statue of Liberty to which Mme. Roland is said to have turned a moment before her execution to cry, 'Oh Liberty! What crimes are committed in your name!'. The bridge, leading from that vast square to the Chamber of Deputies, begun in 1787, was finished in 1790 with stones taken from the ruined Bastille. In the Place des Victoires to replace the gilded statue of Louis XIV (the *Roi Soleil*) stood a pyramid inscribed with accounts of the victories of the Republican armies. The Place Vendôme, then called the Place des Piques (Pikes), and earlier, Place Louis-le-Grand, was also given a statue of Liberty. Dedicated to the patriotic victims of 10 August, additional monuments were ordered for the Place des Victoires and for the Panthéon.

65 To replace the equestrian statue of Henry IV, which had stood on the Pont Neuf since 1635, David, in 1793, proposed an immense piece of sculpture, 52 feet high, holding the figures of Liberty and Equality in one hand, and in the other, the great punitive club of Hercules (read his description of the work in your Sources and Documents, Eitner, *Neoclassicism and Romanticism*, p. 141).

66 It wasn't only sculpture that was to adorn the city. The Deputy, Thibaudeau, on 11 May 1794 spoke of placing in *all* public streets and squares, images of Brutus, Lepelletier, Marat, Liberty and Equality, painted and engraved by patriotic artists.

67 The Louvre museum was to be enlarged. A statue of Rousseau was designated for the Champs-Elysées. A Temple of Equality, a vast covered arena in which to hold fêtes, was planned. So were triumphal arches and colonnades. Statues were to appear everywhere. And not to neglect other aspects of Roman virtue, public swimming baths and gymnasiums were included.

68 The so-called *Plan des Artistes* conceived by David, almost seventy years in advance of Haussmann (commissioned to rebuild Paris) and other urban engineers, involved, in essence, the complete reconstruction of old Paris and of other cities too.

69 The immediate plans of David, Granet and Fourcroy, his associates in the Committee of Public Safety, were prodigious. They promised much work for artists. The Tuileries palace and gardens were to be 'beautified in accordance with classical and Republican taste'. The architect Hubert submitted a scheme for the embellishment of this important central area. The entrance was to be enlarged, with two porticos displaying (presumably in bas-reliefs) the most memorable events of the Revolution. The courtyard of the Carrousel was to be enclosed by a set of circular steps, with statues of the Republican virtues carrying appropriate inscriptions. Numerous other statues, pools, fountains, bushes and trees in large pots, were designated for the gardens. One area was to be put aside for gymnastic exercises. A vast esplanade would be built on the Orangerie side where people could assemble during public festivals. To the statue of Liberty already in the Place de la Révolution, would be added another, and larger, one. Colonnades in the Tuileries gardens were to be joined by a triumphal arch recording the victories of the people over tyranny. It would frame a view through to the church, the Madeleine (not the present one), which was itself to be finished to become a Temple of the Revolution. Facing this arch was to be built another to become part of the monument to the 10th of August festival. Between the two arches would be put two fountains covered with revolutionary emblems.

70 Other plans were made for fountains, statues, and for enlarging and changing roads and squares in the immediate vicinity of the Tuileries. Antique bronzes taken from the collections of the emigrés who had fled France, and from other proscribed people, were to be set on the Bridge of the Revolution which led off the square. None of this work had yet been done, and David and his colleagues were urged (on 9 June 1794) to expedite the plan by submitting full details to the Committee.

71 Of all the grandiose proposals for sculpture, paintings, temples, arenas and other monuments, few indeed were carried out. Time and again the *Moniteur* comments: 'Cette statue n'a jamais été exécutée'. The last reckoning was made in June of 1794. Thermidor was just a month away and with the end of Robespierre David's plans too came to nothing.

72 The eclipse of the great plan is perhaps best symbolized by the few statues in plaster, never to be turned into bronze or marble, like that of Liberty in the Place de la Révolution to which Mme. Roland addressed her sorrowful words. They were left to crumble into ruin.

Revolutionary Festivals

73 In later years, the exiled David looked back with nostalgia to the revolutionary festivals organized and designed by him from 1790 to 1794. He recalled fondly the exciting visual effects: the statues, the young girls throwing flowers, the

decked-out chariots. He remembered the music: the marches, songs and hymns. He may have remembered, too, that on the eve of his last festival, just before the axe fell on Robespierre and the Montagnards, a vast and elaborate plan institutionalizing the fêtes and conceived with his help, had been proposed by Robespierre in the National Convention. Though the initial organization of the plan was put into the hands of the Committee of Public Safety, it is most likely, because of the brilliant successes of his other fêtes, that responsibility for their design would have gone to David.

74 These festivals, at first valued as propaganda for the Republic, later changed character. They became part of a deliberate process in the dechristianization of France. After a long and important speech to the Convention on 18 Floréal (7 May 1794) Robespierre proposed that each year the French Republic should celebrate fêtes on the anniversaries of the significant revolutionary dates: 14 July 1789, 10 August 1792, 21 January 1793, and 31 May 1793. Additionally, every ten days ('les jours de décadi') another fête would be held.

75 Robespierre's list contained thirty-six different themes for the décadi festivals. They ranged from those held in honour of Nature and the Supreme Being, to humankind, to the benefactors of humanity, to the martyrs of liberty, to the liberty of the republic, to the liberty of the world, to the hatred of tyrants and traitors, to truth, to justice, to glory and immortality, to friendship, frugality, and courage, to stoicism, to love, and even to youth and old age, to agriculture and industry and to posterity.

76 In view of what is said in the two preceding paragraphs, for what do you think were these festivals (every ten days) a substitute?

77 They were gradually to take the place of traditional Sunday religious services. In fact, about this time it was decreed that all celebrations of the 'ancient Sundays' were to be punishable by fines and ostracism.

78 Just think of the immensity of the plan. Most of the fêtes already held were exceedingly elaborate. Many artists worked with David in their execution. The problem of storage and maintenance were considerable. Dowd, referring to documents of the time, describes the paraphernalia of the fêtes:

> First of all was the physical equipment: the stationary but temporary monuments, such as colossal statues, arches of triumph, columns, temples, altars, and even mountains which punctuated the line of march; then there were the warehouses full of moveable items, such as the [chariots], floats, and litters used to transport the various emblematic devices as well as the costumes, standards, and banners which figured in the procession; finally there were the inscriptions, paintings, bas-reliefs, and other symbolic décor, inspired largely by classical antiquity, which adorned these physical objects. A small army of dressmakers, carpenters, painters, and other artisans was required to fabricate and maintain this equipment: at a cost of 100,000 livres per month in the spring of 1794. (*op. cit.*, pp. 128–9.)

In this way, of course, the Revolution re-employed the artisanry of Paris, 'till then mainly dependent on the aristocracy and the Church.

79 The attendance figures at the fêtes have often been disputed, usually according to political persuasion. Figures given for the festival of Liberty, held on 15 April 1792, range from 500,000 down to 'very few spectators'. Dowd basing himself on several contemporary accounts, estimates that at least 100,000 were present.[1]

1 i.e. about one fifth of the entire population of Paris, estimated to be about 500,000 around 1800.

Similarly, reports on the enthusiasm of both participants and spectators vary. But, all views considered, the festivals were not only heavily attended, especially by the working people, but evoked lavish expressions of patriotism and fraternity.

80 The fête of Federation: held on 14 July 1790 to celebrate the destruction of the Bastille, was David's first. Not including the funerals for the revolutionary martyrs already discussed, he designed and directed six major festivals and a few smaller processions. From all accounts, they were brilliantly conceived and immensely successful.

81 The Deputies were not slow to realize the propaganda potential of the fêtes; no greater affirmation of that being made than Robespierre's extravagant proposal.

82 Festivals, of course, were not confined to Paris and no less effective ones were held not only throughout France but, in sympathy for the Revolution, in the French colonies and even, in February 1793, in Boston.

83 The idea of sponsoring such festivals officially in revolutionary France, sprang from a popular base, and, inevitably, they took on all the character of ancient Roman celebrations. After the 1789 revolution, spontaneous demonstrations had occurred throughout the country with the purpose of pledging large numbers of people to unification in combating the common enemy, however ill-defined that enemy was. From the first, these fêtes were quasi-religious, with the blessing of the banners of the National Guard and even with Mass being said. During the Fête of Federation, Mass was celebrated on a great altar of *La Patrie* (The Fatherland, The Nation).

The Triumph of Voltaire

84 As the rupture grew between the Church and the Revolution (church property had been confiscated in 1789 and all priests were required to swear allegiance to the Constitution in 1790), the festivals became more pagan in character. The first fête with a strong flavour of antiquity was held on 11 July 1791 in honour of Voltaire (who died in 1778). It was a deliberate insult to the Church in Paris, where the 'father of the revolution', so-called, had been denied a Church burial. It was also an answer to the Pope, who, earlier that year, denounced the Assembly's Civil Constitution for the Clergy.

85 The achievement of Voltaire's apotheosis, and another blow to the Church, was his burial in the Panthéon. The building, in the form of a Greek cross, conveniently in the neo-classical style, stands on the consecrated ground which once contained the tomb of Geneviève, patron-saint of Paris. The church itself, dedicated to the saint, had been converted by the Constituent Assembly early in 1791 into a Panthéon, or a place for the burial of the great. Since the king had taken flight less than a month before the festival day (only to be captured and brought back) the propaganda base of the festival was expanded also to become anti-royalist.

86 The fête lasted all day, starting at the Place de la Bastille in the early morning, and, lit by the torches of David's students, ending at about 9.30 p.m. at the Panthéon. As in church processions, 'stations' were used; in this case the cortège stopped at the Opéra, at two theatres, the Comédie Italienne and the Comédie Française, and a few other places, each time to hear speeches, take oaths and to sing hymns to the Republic. A stop was made at the Tuileries Palace 'beneath the windows of the Royal prisoners'.

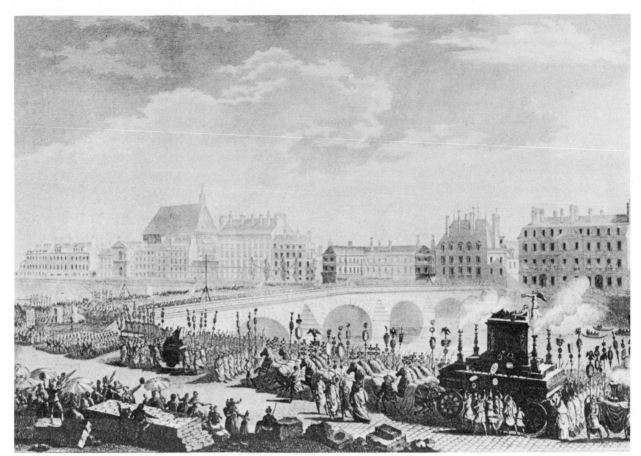

87 This contemporary engraving (Fig. 7) shows the procession as it filed past the Tuileries Palace towards the Pont-Neuf. How accurate a record it is cannot be said, though very likely it was conceived in a somewhat idealistic frame of mind. The huge triumphal car carrying Voltaire's remains and pulled by 'twelve' white horses can be seen in the print. Many of the figures are dressed in Roman costume, and carry standards with eagles such as were known in the Imperial Roman Army. On the many staffs and maniples shown are crowns, wreaths and medallions which in Rome were marks of military distinction. The similarity of these staffs to the pikes of the sans-culottes hardly needs to be pointed out.

Fig. 7 Contemporary engraving of a scene from David's festival of Voltaire, 11 July 1791.

88 Every detail of the fête was planned by David and an assistant named Célerier. Even the musical instruments were based on David's designs from Greek and Roman models. His Roman sketchbooks served him well here. The banners were covered with mottoes. Medallions showed the features of Rousseau, Mirabeau (the first revolutionary hero to be buried earlier that year in the Panthéon) and Benjamin Franklin. Even a model of the Bastille was carried.[1] The procession was made up of distinct groups including the National Guard, the Military, government officials, students, the workers from the famous Faubourg Saint-Antoine and the Paris market porters – among others.

89 Several descriptions of the fête exist, and the general opinion is that the event met with great approbation and enthusiasm. All along the route people gathered in huge throngs and crowded on to rooftops and in the windows. The highest estimates say 200,000 participated. 'It marked [writes Dowd] another step in the development of revolutionary religion; the introduction of neo-classical art and atmosphere into civic celebrations. It set the pattern for the subsequent propaganda festivals of the revolution.'

1 There was at the time a lively trade in stone models of the Bastille made from the actual ruins of that structure.

27

The Cult of Reason

90 The demand that Catholicism be replaced by the religion of the *Patrie* was by the end of 1793, with the 'Terror' in full spate, frequently and resolutely made. More and more, even the 'Constitutional' clergy (those who had taken the oath of loyalty) came to be regarded as enemies of the Republic. Hopeless about their position, all through France priests and Protestant ministers, even bishops, were unfrocking themselves and ceremoniously donning the *bonnet rouge* putting, as it was expedient to do, country above religion. In some cases, priests genuinely went over to the new faith. The concept of dechristianization gained force and many churches were turned into 'Temples of Truth' or 'Temples of Reason'.

91 Marie-Joseph Chénier, dramatist and author of most of the lyrics for the songs and hymns of the fêtes, declared that the new religion would be founded

> on the shards of dethroned superstitions, the only universal religion, which has neither secret nor mysteries, whose dogma is equality, whose sermons are our laws, whose pontiffs our magistrates, and which asks the human family to burn its incense only before the Altar of the Country, our common mother and divinity.

92 On 20 Brumaire in year II (10 November 1793) the Church of Notre Dame in Paris was turned into a 'Temple of Reason' with the approval of the Paris Commune (i.e. the local government). Two weeks later the Commune passed resolutions stating that all Churches and Temples in Paris, of whatever religion or sect, will be closed immediately. In Notre Dame, everything that suggested the Christian religion was if possible covered. At one point it was planned to destroy the sculptures of Saints on the portals, but they were boarded up instead. Some reports say that the sculptures were 'mutilated'. Drapes were put up, probably in the crossing, cutting off the choir to create a central focus-point. Here, a simulated mountain (symbolic, probably, of Nature) was erected with a little round temple, Greek style, on top, inscribed with large letters, 'TO PHILOSOPHY'. A 'Torch of Truth' burned halfway up the mound in a little Greek altar, and in the Temple was placed an enthroned figure of Reason. On the 'mountain' were placed busts of four philosophers, probably Rousseau, Voltaire, Franklin and Montesquieu. At the temple, on a throne made of green boughs, sat what is described as 'a beautiful woman', an actress from the Opera (possibly Maillard, the ballet-dancer, though her actual identity is disputed), in a white dress, blue cloak, and wearing the red bonnet. She carried a pike. She was Liberty. A group of young girls in white with garlands of flowers, tri-colour sashes and carrying torches, paid homage to Liberty at the altar. Hymns were sung to her as, with outstretched arms, she re-entered the temple.

93 There is no evidence to indicate that David had anything to do with this event. He must, at the time, have been occupied with the new 'Jury of the Arts' for which he was to select all fifty members. Furthermore, his immediate obligations were with the National Convention and not the Paris Commune. And over the question of how dechristianization would be brought about the Commune and the Convention were in serious and fundamental conflict.

94 The Convention, it seems, had not been invited to the ceremony until it was under way. The Commune was possibly apprehensive that their plan, if known earlier, would meet with disapproval and steps taken to prevent it. But now that the festival of Reason was a *fait accompli*, it was literally carried out of Notre Dame right into the Hall of the Convention. There, probably to the disgust of Robespierre, Danton and half the deputies, the ritual of Reason was re-enacted. The figure of Liberty was brought in surrounded by the young girls. She was taken to sit beside the President and even got a kiss from him. The

Paris legislature came in force to sing more patriotic hymns, in which the Convention joined. Then about half the Convention went to Notre Dame where the original ceremony was re-enacted. 'In reality the Convention was more astonished then seduced, and believing the movement irresistible, followed it'. (A. Aulard, *The French Revolution*, trans. 1910 and *Le Culte de la Raison et Le Culte de L'Être Suprême*, Paris 1904).

95 But irresistible the movement was – to much of France it seems. Strongest, where it was nearest the 'enemy': Catholic Austria and Spain, it was lavishly indulged in Strasbourg and Perpignan. So violent was the anti-religious fanaticism in Perpignan (due largely to the success of the Spanish armies over the French) that the most ferocious iconoclastic indignities were perpetrated, with statues of the holy family and of the saints put on pyres and burnt to the din of patriotic harangues, patriotic tunes and festive dances. On 16 Ventôse (6 March 1794) a large group of patriots were led by the Deputies Milhaud (see plate III) and Soubrany to a spot where they ceremoniously 'pissed Jordan water' on the head of Jesus. Then, on the beach near Perpignan, a reported 500 religious statues were consumed in a pyre so large that it was believed (hopefully) that the column of smoke could be seen across the border in Spain.

96 The most impressive feast of Reason, according to Aulard, took place at the Cathedral of Chartres on 9 Brumaire (30 October 1793) even before that of Notre Dame. It drew more people, he says, than Catholicism in its grandest rites had ever done. All religious emblems were covered by those of the Cult of Reason. The statues in front of the cathedral were removed and replaced with others representing Humanity and Force on the left, and on the right, Liberty and Equality. A tribune in the Roman style became the pulpit of Truth. A 'mountain', about 25 feet high, was constructed in the sanctuary of the church and set about with actual rocks, trees and grass turfs. On its summit was placed an oak tree crowned with a red bonnet. On one branch a cock held in its beak a tri-coloured sash. From one of the rocks a moral discourse was delivered. Before the altar, musicians from the theatre at Chartres played a piece called 'Reason victorious over fanaticism'. The whole was strongly reminiscent of the old mystery plays. 'Fanaticism', played by a monstrous figure, was revealed by 'Watchfulness'. A simulated dialogue against fanaticism was held between Rousseau and Voltaire. A figure in a tri-coloured robe then came on to the sound of the *Marseillaise* and with her lance pierced the monster of fanaticism. The National Guard followed, tipping over the old altar and trampling it under foot in a ritual destruction of all the attributes of the Church. They 'despoiled' it of its 'vain ornaments', heaping them up and then 'throwing its corpse' from the sanctuary. At that moment the figure of the Republic took a flaming torch and with it illuminated an artificial cloud. She ascended one side of the mountain and there, aided by some mechanism in the form of a thick cloud, she was picked up and carried to the height of the statue of Reason. Into the hand of this statue she put the torch which served to light up the whole scene. The thick cloud was made to 'melt' away, revealing to the spectators a new world composed of a huge group of little girls dressed in white, and young boys in the costume of the National Guard. Then, the Deputy Thirion got up on the mountain and delivered a patriotic speech which ended the ceremony.

97 It was easy, as Aulard suggests, to insult Christianity, but not to supplant it. Some of the paraphernalia and ritual of the old Church was still employed, and Priests of Reason were appointed to officiate on Republican high feast days and at weddings, and to conduct Republican invocations, salutations, credos and hymns. Republican catechisms followed precisely the Catholic formula:

Q. What is baptism?

A. It is the regeneration of the French, beginning on 14 July 1789 and soon supported by the whole French nation.

Q. What is confirmation?

A. It is the formation of the National Convention which, correcting the many faults of the previous Assemblies, has totally abolished royalty, and substituted a Republican régime.

And so on with, 'What is communion?' and 'What is penitence?'.

98 There is some indication that despite the sincere attempts, especially in the provinces, to get rid of the old religion, the popular masses tended to ignore, or even despise the cult. This, Aulard thinks, is because the rituals became too learned, and were followed mainly by a well-off, well-educated élite. And this, he says, is why it disappeared so rapidly, 'without leaving any traces on the national soul'.

99 Robespierre felt a great repugnance for the Cult of Reason. His silence during its first flowering may have concealed the conviction that it would soon burn itself out, or at least become weakened enough for him to step in and set things right. He and many others grew alarmed at the audacity of the cult, both on political and religious grounds. Politically, he feared that the blasphemous acts committed against Catholicism would bring upon France even more resolutely the united wrath of her external enemies in Europe. Politically, also, and notwithstanding his own brand of radicalism, he resisted its revolutionary ardour and genuinely radical character. Religiously, he saw in the Cult of Reason, not the gradual eclipsing of Catholicism by a new religion, but in the Atheism of the cult, the abolition of religion itself.

The Cult of the Supreme Being

100 As the Cult of Reason spread, with parish churches all over France turned into Temples of Reason, the inevitable fear of its trivialization arose, even among its most energetic advocates. At this point Robespierre, supported by Danton and others, began their counter-attack. On the first of Frimaire (21 November 1793) Robespierre in the Convention protested against the violation of religion *as religion*. He insisted that 'the idea of a great Being who watches over oppressed innocence and who punishes crime triumphant is essentially of the people'. Imploring the Convention to stamp out Atheism and institute a new and *religious* cult, he uttered Voltaire's well-known phrase, 'If God did not exist we should have to invent Him'.

101 Thus it was that on 18 Floréal (7 May 1794), after a long and impassioned speech condemning Atheism and the Cult of Reason, Robespierre declared that the French people must recognize the existence of the Supreme Being and the immortality of the soul, and that a cult worthy of the Supreme Being ought to be practised by everyone.

102 Robespierre, Aulard says, saw the Supreme Being not as a substitute for Christianity, but as a purified Christianity. With David instructed to prepare the detailed plan, a fête in honour of the Supreme Being was to be held on 20 Prairial (8 June 1794). It is this festival that will be re-enacted in the television programme that goes with this unit.

David after Thermidor

103 It was David's good fortune to be ill and absent from the Convention on the night of 9 Thermidor (27 July 1794) when Robespierre was brought down. Though he escaped the fate of his friends, David was nevertheless denounced four days later. His plea in his own defence failed. He was rather taken into custody than jailed on 2 August. That is to say, he was 'incarcerated' in the studio of a pupil where he was allowed to paint and receive visitors. David survived another denunciation late in August, during a purge of Robespierre's former cohorts. Though he was obliged to remain in confinement, he was still able to paint. He again appealed to the Convention on 17 November, re-asserting his Jacobinism and devotion to its 'noble cause', a mark of sincerity which may have worked in his favour. At this point he became reconciled with his estranged wife who, with his devoted students, spoke up on his behalf, to some effect it seems, for on 24 December David was granted a two-month discharge. His enemies relentlessly brought a string of charges against him. Though he countered them effectively, he was re-arrested. In August 1795, a year after he was first taken prisoner, he was permitted to stay under guard first at the home of his wife, and soon at that of one of his brothers-in-law with whom he was on friendly terms.

104 As 9 Thermidor grew more remote, David's chance of survival increased, and in the face of his great talent, only the most vindictive worked for his ruin. He now led a hermetic existence, giving time to his pupils and painting some of his best-known portraits and works like *The Sabine Women* (finished in 1799).[1] His political views apparently remained unaltered and he continued to praise the Republic.

105 When Napoleon came to power, David threw himself wholeheartedly into Bonapartism. It is for this he is thought to have acted inconsistently, though writers like Friedlaender do not see anything strange in David's devotion to Napoleon (Friedlaender, pp. 20–21).[2] Some of David's greatest paintings were made under the Empire (ibid. pp. 27–30). After Waterloo, David fled in exile first to Geneva and then to Brussels where, at the height of his reputation as a painter, he died in 1825.

1 The drawings for this painting were begun in 1794. It seems to be a work in honour of his wife who, though she had broken with him, came to his support in time of trouble. The theme of the painting is one of reconciliation.

2 Arnold Kettle comments that Stendhal, like David, was a Jacobin who welcomed Napoleon as a defender and developer of the Revolution, though he became critical of him when he made himself Emperor. See Unit 28.

APPENDIX I DAVID'S SPEECHES (see paragraph 37)

LEPELLETIER

Citizens, each one of us is accountable to the fatherland for the talents which Nature has given us; if the form differs, the purpose should still be the same for all. The true patriot should seize with eagerness all the means open to him to enlighten his fellow citizens and to present continually to their eyes sublime examples of heroism and virtue.

This is what I have tried to do in the homage which I now offer to the National Convention, in the shape of this painting showing Michel Lepelletier cowardly struck down because he voted for the death of a tyrant.

Citizens, Heaven which distributes its gifts to all its children, desires that I should express my soul and my thought through the medium of painting, rather than through the sublime eloquence and persuasive voices that the vigorous sons of liberty raise among you.

Respecting fully its immutable decrees, I am silent, and I shall have fulfilled my task if I can one day make an old father, surrounded by his numerous children, say 'Come, my children, come and see this man, one of your representatives, the first, who died to give you freedom; see how serene his features are; it is because when one dies for one's country there are no regrets. See the sword which hangs above his head, and which is suspended by nothing but a hair. This, my children, is to show you what courage Michel Lepelletier, and also his brave colleagues, needed to punish the infamous tyrant who had oppressed us for so long, since with the least movement that hair might have broken and they would all have been inhumanly slaughtered.

Do you see this deep wound? You weep, my children! you turn away your eyes! But pay attention too to this laurel wreath, it's the wreath of immortality; the fatherland holds it ready for each of its children; know how to be worthy of it; for great souls there are always opportunities to win it. For example, if ever some ambitious person should speak to you of a dictator, of rulers, of an overlord, or should try to usurp the smallest portion of the sovereignty of the people, or if some coward dares to propose a king, fight or die like Michel Lepelletier rather than ever agree to it; that way, my children, your reward will be the crown of immortality.

I beg the National Convention to accept the homage of my feeble talent. I shall consider myself well rewarded if it deigns to receive it.

> (David's Lepelletier speech is translated in your Eitner, *Neoclassicism and Romanticism* anthology, but the version above is I believe closer to the original.)

MARAT

Citizens, the people ask for their friend again, their sorrowful voice wished itself heard – my talent is roused, they want to see again the features of their faithful friend: David! they cry, seize your brushes, avenge our friend, avenge Marat; let his vanquished enemies grow pale again at sight of those ruined features, reduce them to such a state that they envy the fate of him whom they were cowardly enough to have killed when they could not succeed in corrupting him. I heard the voice of the people; I have obeyed.

Come here all of you! mother, widow, orphan, oppressed soldier; all of you whom he has defended in danger of his life, draw close! and look upon your friend; he who will never wake again; his pen, the terror of traitors, his pen has fallen from his hands. O despair; our indefatigable one is dead.

He is dead, your friend, he dies giving you his last crust of bread; he is dead and so poor he doesn't leave enough even for burial. You, posterity, will avenge him; you will tell our descendants what riches he might have amassed if he had not preferred virtue to fortune. Humanity, you will tell those who called him blood-drinker, that your darling child, your Marat, never made you shed a tear.

I call on you, foul calumny, yes you yourself, yes, I shall see you one day, and that day is not far off, stifling with your two hands your withered serpents, dying of rage, swallowing your own poisons.

And we shall see the defeated aristocrat, confused, no longer daring to show himself.

And you Marat, from the depth of your tomb, your ashes will rejoice, you will no longer regret this mortal shroud, your glorious task will be complete, and the people, crowning your labours a second time, will carry you in their arms to the Panthéon.

32

It is to you my colleagues that I offer the homage of my brushes; your gaze as you look over the pale and bloody features of Marat, will recall to you his virtues, which should never cease to be yours also.

Citizens, when our tyrants, when error still led public opinion astray, public opinion took Mirabeau to the Panthéon. Today the virtues, the efforts of the people have destroyed prestige, truth is revealed, before her the glory of the friend of kings vanishes like a shadow, let vice and imposture flee the Panthéon; the people call to it the man who never betrayed them.

I vote the honours of the Panthéon for Marat.

Fig. 8 Charles Philipon from a photograph by Nadar.

Fig. 9 Honoré Daumier from a photograph by Nadar.

Unit 30 THE ART OF CARICATURE IN THE JULY MONARCHY

Charles Philipon – Impresario of Caricature

106 'The Revolution of 1830 [wrote the poet and critic Charles Baudelaire] like all revolutions, caused a fever of caricature. It was truly for caricaturists a great period. In that ruthless war against the government, and particularly against the king, one was all passion [coeur], all fire.' (*Curiosités Esthétiques*, 'Quelques Caricaturistes Français.')

107 Baudelaire, writing about 1851, was thinking particularly of Charles Philipon (1800–1862) and his small army of artists who declared war, with pictures mainly, but also with words, against the abuses and absurdities of the government of Louis-Philippe. Coinciding with the appearance of the July Monarchy, Philipon founded the weekly journal, *La Caricature*; its first number appeared on 4 November 1830. Each issue was to carry two lithographs by some well-known artist, plus one page of text. Some of the articles were written by Balzac, under a *nom-de-plume*. Two years later, Philipon began to publish a daily called *Le Charivari*, on which was modelled *Punch*, or, as it was then called, 'The London Charivari'. The word, 'Charivari' was meant to convey the noise of the streets; 'derisive serenade' is the term used. Philipon stated flatly that he was prepared to play this 'serenade' for anyone who gave support to the king. Never before in history had there been so concerted an effort to use caricature, in a deliberate and calculated way, as a vehicle of political invective. And never, perhaps, were artists led by such a spirit as Philipon.

108 Philipon was born in Lyons. His father ran a wallpaper factory, and after an erratic education and a short time in Paris in the studio of David's student, the painter, Gros, he went back to his native city for three years to design wallpaper. He threw this up in 1823 and returned to Paris. There he associated with liberal writers, their ideas confirming in him his own vague political beliefs.

109 To earn a living and at the same time to find a means for expressing these beliefs, he turned to the relatively new technique of lithography. Lithography was the only print-making process by which pencil or crayon sketches could be reproduced exactly as they were originally conceived. With this method the drawing is executed directly on to a limestone slab using a crayon with a high grease content. The image is then removed, leaving a greasy residue in its place. In printing, the stone is moistened, the ink adhering only to the parts from which the original drawing has been removed. Because of its directness, its speed and printing capacity, lithography was the perfect medium for the caricaturists of the time.

110 Because of the regulations which governed the press Philipon was soon faced with an avalanche of lawsuits – it is said as many as fifty-four in one year alone. He was involved in many other pictorial publications, among them the *Musée Philipon*, *Physiologie*, and the *Journal pour rire* which survived well into this century. His life was a succession of confiscations, litigations and fines, punctuated by short stretches in prison. For publishing this drawing, *The Press is Perfectly Free* (Fig. 10) in *La Caricature* in 1831, Philipon was sentenced to six months in prison and fined 6,000 francs. Here, the weight of actions against the press, of fines and duties, are shown to render it immobile.

Fig. 10 Charles Philipon. The Press is Perfectly Free. *1831.*

111 One of the most glowing testimonies we have of the genius of this man is the obituary written soon after his death in 1862 by the famous caricaturist, photographer and balloonist, Nadar (Félix Tournachon). According to Nadar, Philipon played an important role in the destiny of France, a statement which may amply be confirmed. Philipon had a kind of force in political debate that pierces when it touches, writes Nadar – like the barbs on an arrow which you don't feel until the thing is in. Philipon had a 'precious faculty' for showing others the way and he sketched out the formulae for almost all artists working at the time in the same genre. Nadar comments on Philipon's unique flair for recognizing talent, and this we can see by the sparkling phalanx of draftsmen he recruited to his colours: Daumier, Gavarni, Grandville, Pigal, Traviès, Forest, Bouquet, Duperret, Rambaud, Décamps, Monnier, Cham, Johannot and yet others including, later, Nadar himself. Most of the inscriptions that go with Daumier's early lithographs were supplied by Philipon.

112 With his 'unparalleled sharpness of vision and rapidity of execution, Philipon astonished and disconcerted younger and keener people right to the end of his sixty-two years'. He commanded an 'inexhaustible' fund of invention and means of putting across his messages. 'He had an energetic personality, completely steeped in his world'. He lived fully, writes Nadar, still laughing despite seeing so much corruption, and to the last remained passionate for politics, without fear. Philipon, he says, was always ready to help people, digging into his pocket or taking steps on their behalf. Working ceaselessly, Philipon was able to resist all the long and terrible intimidations from the law. To the last, when he was beset with the illness that killed him, he remained implacably young, through his 'infinite goodness and his ability to remain indignant'. There was the man 'who with a joke could make a throne tremble'.

Louis-Philippe (1773–1850) and the July Monarchy (1830–1848)

113 The throne 'trembled' more, it seems, out of rage than fear. It is sometimes argued that Louis-Philippe was not as bad as his detractors made out. Let's look

at the record – briefly. Louis-Philippe and most of his family had supported the Revolutions of 1789 and 1830. His father, Duke of Orléans, was instrumental from 1787 in giving a shape to the grievances of the Third Estate. He even took the name Philippe Egalité, and though he voted for the death of the King, incurring the wrath of the nobility, he nevertheless later joined the many other liberals at the guillotine. Louis-Philippe at age sixteen was received into the Jacobin Club and as a young man, took the surname, Egalité. He fought in the revolutionary army at Valmy and Jemappes in 1792, though in 1793 he went over to the Austrians. He was involved in the July uprising that marked the 1830 Revolution. On taking office in 1830 he declared: 'On entering the City of Paris I wore with pride those glorious colours you have resumed, and which I had myself long carried'. This is why Jacobins like Stendhal, who heard the news of the 1830 Revolution as he was correcting the proofs of *Scarlet and Black*, welcomed the Revolution. It was bound, he felt, to usher in something better than the France of the Restoration.

114 With the success of this Revolution and the abdication of Charles X, Louis-Philippe accepted, at the age of fifty-seven, first, the Lieutenant-generalship of France (July 31) but in a few days had it converted to a new regal role: that of a constitutional, parliamentary monarch. Still, he was not there by divine right. He showed the tri-coloured flag of the Revolution and was designated King of the French rather than King of France, a distinction with some meaning. He wisely refused to take the title, Philippe VII, which had been suggested. His intentions, however conservative, seem to some historians to have been honourable. For what it was worth, he promised publicly to revive republican institutions. He promised to establish the rights of man and equality before the law. He guaranteed freedom of worship. He declared that he would abolish censorship for all time, a welcome relaxation of the severe censorship laws under the previous régime, and without which it may be doubted that caricaturists like Philipon could ever have got started (but see paragraph 184).

Conscription would be abolished. Democratic reforms were made concerning local elections. In a few years he approved of the introduction of a new education act which significantly increased the number of schools and students in France. In general, Louis-Philippe pushed the country closer to a parliamentary democracy than it had ever been. He managed foreign affairs well and apart from the conquest of Algiers, kept the peace. For those politicians like Adolphe Thiers who'd manipulated him on to the throne it appears to have been a way of depriving the Republicans of their revolution. And it became increasingly apparent that the rules were made to satisfy the well-to-do. Suffrage for the lower orders was only increased by a minute degree, less than one per cent of the entire population entitled to elect the representatives to the Assembly. Not everyone could qualify for the vote by owning property or having income above a certain value. Neither was there any indication that there would be a progressive movement towards the universal franchise. Louis-Philippe's government, as is said more precisely and with some justification, was not a 'bourgeois monarchy' but an 'oligarchy of landowners' (Alfred Cobban, *A History of Modern France*), though not all historians would agree.

115 Louis-Philippe is described as 'stubborn, realistic and thoroughly unscrupulous'. He is said to have 'concealed a passion for power under a good natured exterior'. His monarchy was 'based on the myth of a bourgeois king' (Jacques Droz, *Europe between Revolutions 1815–1848*). Louis-Philippe is characterized as lacking in style, gossipy, fussy, undignified and smugly complacent (Cobban, *op. cit.*). He deliberately avoided reading the newspapers, and works of the political opposition, like those of the Socialist Louis Blanc held no interest for him. Curiously, he read the *Times* and the *Morning Chronicle* to keep abreast of

things in England. His government was an élitist one and despite a vague current of liberalism which ran through it, it was essentially based on privilege. His ministers, like Thiers, Guillaume Guizot and Apollinaire d'Argout cared little for social and political equality and ran the government as though it were their own private business. Balzac in *Cousin Bette* has one of his grotesque characters – Rivet, the prosperous owner of a tailoring factory which makes decorations for uniforms – say, 'I worship Louis-Philippe. He is my idol, he is the august and perfect representative of the class on which he has founded his throne, and I'll never forget what he has done for the trimming trade by re-establishing the National Guard . . .'. As criticism mounted, especially from the press sympathetic to Republican ideals, and as outbreaks of violence occurred, inspired occasionally by Legitimist factions, the government took repressive action. In June 1832, and also in 1834, Paris rose again in rebellion. As early as 1831, weavers in Lyons took temporary control of the city. Republicanism grew in strength. Its main purpose: to implement the rights called for earlier by Robespierre and the revolutionary Convention of the 1790s, but this time with an increased consciousness of the needs of the humbler classes.

116 One of the things that marks the July Revolution and the so-called July Monarchy is the conception of the workers as a political force and an acute awareness of their rights and social problems. Some early socialist doctrines on wealth and wages were for example formed in those years – as were utopian principles for daily living. Many playwrights, novelists and artists, the latter especially as caricaturists, were moved to portray the lives of the 'little people', not a new, but a more important subject matter. Social and political caricature, which sprang to life with the freedoms promised by the July Revolution, ironically turned against the new order, frustrated and embittered, convinced that one reactionary régime had simply been supplanted by another.

The Saga of the Pear

Fig. 11 Photograph of Louis-Philippe taken in 1840s.

117 Of all the weapons in the armoury of the caricaturist, none was so effective as the simple pear. In French, pear is *poire*, but it has a whole range of other, and subtle, meanings. *Poire* is slang for nut, noggin, blockhead, fathead, or mug. It also means 'easy mark', and '*faire sa poire*' is to fancy oneself.

118 Here is a photograph of Louis-Philippe (Fig. 11). If you were a caricaturist like Philipon or Daumier, and wanted to get at the king in his most vulnerable spot, you might find the analogy with a pear quite rewarding.

119 Most caricaturists of the period did. They saw or forced themselves to see in the physiognomy of the king a resemblance to the pear. Innumerable representations were thenceforth made of the hapless Louis-Philippe in that form, many of them brilliant in their variations on the theme. Unmercifully the caricaturists hounded the king with that image. It became a universally comprehensible symbol of ridicule for the régime. Shapes like pears were found in the most unlikely places (Fig. 12).

LE BOEUF GRAS DE 1834.

Fig. 12 Eugène Forest. The Fatted Ox of 1834. *Published in* Le Charivari.

120 But the etymological significance of the word, its multiple meanings, was always the barb that went in with the arrow.

121 Daumier alone accounted for a number of lithographs and drawings in which in one guise or another the *poire* figured. But to give it additional satirical power the joke had to be clothed in larger, and if possible, more ridiculous contexts. It wasn't always enough just to show the king in the same old, should I say, ap-pear-ance. If that were all the artists could do, the idea would soon wear thin and dis-ap-pear.

122 Several references to pears are made in this lithograph signed Rogelin (Fig. 13), which was published in *La Caricature*, 23 February 1832 with the title *Le Cauchemar* (The Nightmare).
It is, in fact, by Daumier, and though the pseudonym suggests that he was evading the censor, it is usually believed that the signature contains an obscure reference, undoubtedly satirical, to one of Louis-Philippe's sons, nicknamed 'Rosolin'. The same signature appears on the *Masks of 1831* (Fig. 17) though its meaning there is also unclear.

Ropelin

Fig. 13 Daumier. The Nightmare. *1832.*

123 During a visit to Paris in 1839, the English novelist, William Makepeace Thackeray, tells of the battle between the caricaturists and Louis-Philippe. 'The Revolution came, and up sprung Caricature . . .' he writes. He describes it as an unfair battle, a battle between a half-dozen poor artists on the one side, and his Majesty, his august family and their supporters on the other. Though the attacks made on Louis-Philippe were often cowardly, false and malignant, he says, the king, writhing under their effects, unleashed an uncouth fury in return, and the fierce blows he dealt at his opponents almost annihilated them.

> The King of the French suffered so much, his Ministers were so mercilessly ridiculed, his family and his own remarkable figure drawn with such odious and grotesque resemblance, in fanciful attitudes, circumstances, and disguises, so ludicrously mean, and often so appropriate, that the King was obliged to descend into the lists and battle his ridiculous enemy in form. Prosecutions, seizures, fines, regiments of furious legal officials, were first brought into play against poor M. Philipon and his little dauntless troop of malicious artists; some few were bribed out of his ranks; and if they did not, like Gillray in England, turn their weapons upon their old friends, at least laid down their arms, and would fight no more. The bribes, fines, indictments, and loud-tongued *avocats du Roi* made no impression; Philipon repaired the defeat of a fine by some fresh and furious attack upon his great enemy; if his epigrams were more covert, they were no less bitter; if he was beaten a dozen times before a jury, he had eighty or ninety victories to shew in the same field of battle, and every victory and every defeat brought him new sympathy. Every one who was at Paris, a few years since, must recollect the famous '*poire*' which was chalked upon all the walls of the city, and which bore so ludicrous a resemblance to Louis-Philippe. [*Paris Sketchbook*, 1840.]

124 The *poire*, says Thackeray, became 'an object of prosecution'. He describes Philipon's celebrated demonstration to the court. The artist began by drawing a pear, 'a real large Burgundy pear' crowned with a few leaves (Fig. 14). 'There was no treason at least in *that*,' said Philipon to the jury. 'Could anyone object to such a harmless botanical representation?

> Then he drew a second pear, exactly like the former, except that one or two lines were scrawled in the midst of it, which bore, somehow, a ludicrous resemblance to the eyes,

nose, and mouth of a celebrated personage; and, lastly, he drew the exact portrait of Louis-Philippe; the well-known toupée, the ample whiskers and jowl were there, neither extenuated, nor set down in malice. 'Can I help it, gentlemen of the jury, then,' said he, 'If his Majesty's face is like a pear? Say you, yourselves, respectable citizens, is it, or is it not, like a pear?'

Fig. 14 Philipon. Les Poires. November 1831. Published c. January 1832.

Such eloquence (says Thackeray) could not fail of its effect; the artist was acquitted, and *La Poire* is 'immortal'.

125 And immortal it was – for generations after. Of all the prodigious satanic comedy which the critic and poet Charles Baudelaire attributed to *La Caricature*, the thing that stuck in his memory was the pyramidal and Olympian *Pear*. It dominates that whole fantastic epoch, he wrote in later years. He, too, relates how Philipon, continually in trouble with the authorities, especially for his objurgatory representations of the king, attempted to prove to the Court of Assizes that his preoccupation with the pear was innocent fun. Baudelaire

also describes how, skirting the edge of the law, Philipon drew for the court a series of sketches, the first of which was an accurate representation of the royal face. Here the procedure described by Thackeray is reversed. Each succeeding sketch, while maintaining the general form, moved further and further away from the original and approached the fatal goal – a pear.

126 According to Baudelaire, Philipon then demonstrated the same process of transformation with the heads of Jesus and Apollo. One of them, as he recollected, ended up looking like a toad. The game of transformation was of course not new, nor did Philipon exhaust it with his famous pear.

As late as 1910 the technique was irreverently used, possibly with Philipon in mind, to disparage a number of political personalities in and out of France. They are metamorphosed from vegetables in the manner of Philipon, but they hardly communicate the subtle layers of meaning in the work of their predecessor (Fig. 15).

Fig. 15 L. Braun. Political satire from Parliamentary Cookery: the fat Vegetables. 'The Tomato', *in* L'Assiette au Beurre, *22 January 1910.*

127 Baudelaire understood the power of that kind of analogy and how the symbol could be turned into a sign – a few lines to denote a pear was enough! Less than twenty years later, he wrote:

> With this kind of graphic slang [*argot plastique*] one had the means to say what one wanted to the public and make them understand. Thus it was that the great band of patriotic protesters focused on this tyrannical and cursed pear. The fact is that it was used in so marvellous a way and with such keenness that despite the obstinacy with which Justice hit back, it is astonishing to us today, when we look through these comic archives, that so furious a war could have gone on for so many years.

128 Considerable ambiguity exists about two versions of *Les Poires*. A possible sequence of events is this: Philipon appeared at the Court of Assizes, 14 November 1831, on a charge of representing Louis-Philippe in *La Caricature* in the form of a pear. To defend himself he made the drawing Thackeray and Baudelaire describe (Fig. 14). Despite the astuteness of his argument he lost his case, and on 19 November was condemned to six months in prison and fined 2,000 francs. Notwithstanding his punishment, and adding insult to injury, Philipon published the drawing made at Court in *La Caricature* about January 1832 as a lithograph with explanatory text. Later, in 1834, ostensibly to raise money to pay a fine incurred by *Le Charivari*, *Les Poires* was revived as a woodcut, published in *Le Charivari* and probably also sold as individual prints (Fig. 16).

The text of the later version, substantially that of the first, says:

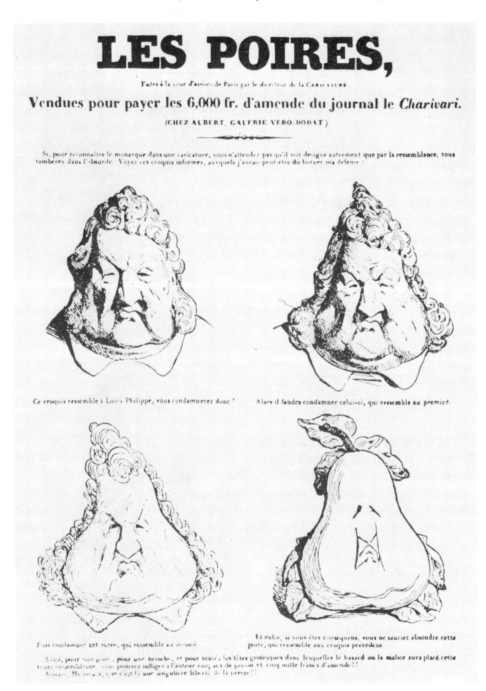

Fig. 16 Philipon. Les Poires.
Woodcut, 1834.

The Pears

Made at the Court of Assizes, Paris, by the director of *La Caricature*.

Sold to pay the 6,000 franc fine owed by the journal LE CHARIVARI.

(published by Aubert, Galerie Vero-Dodat).

If, to see the monarch in a caricature, you don't expect to see him in any form but that of a likeness, you will tumble into the absurd. Look at these rough sketches, perhaps I should have limited my defence to them:

This sketch resembles Louis-Philippe. Do you therefore condemn it?

If so, you must condemn this one also, because it resembles the first.

And then condemn this other one which is like the second.

And, finally, if you are logical, you will not know how to exclude this pear, which resembles the previous sketch.

Thus, for a pear, for a brioche, and for all the grotesque heads in which chance or malice could discern this sad resemblance, you would have to condemn the author to five years in prison and a fine of five thousand francs!! Admit, Sirs, that that is a strange kind of freedom of the press!!

129 For publishing *Les Poires*, Philipon was ordered to print the text of the Court's November verdict in his magazine. The indomitable man still had an ace up his sleeve. As the law demanded, he published it, but with one brilliant deviation. He is said to have set out the actual words in the shape of a pear.

Honoré Daumier (1808–1879)

130 For an artist with such a trenchant wit, Daumier was a genial and modest man. He was, in some degree, an artist's artist, his work highly esteemed by his colleagues. Most of his active life was spent in grinding out drawings for lithographs and woodcuts for the daily and weekly press. Daumier accounted for over 4,000 lithographs in about forty years, plus about 1,000 woodcuts. That's an average of about one every two or three days. Though this means of earning a livelihood prevented him from painting as much as he wished, he managed nevertheless to produce an impressive quantity of several hundred works in oil, in water-colour and some sculpture.

131 Daumier was as capable and robust a draftsman as the best of his contemporaries, though often the open brushwork of his paintings does not readily reveal this. Why not? Because he was on a ceaseless search for an intense and monumental style, for large, bold forms which do not immediately convey the deft and subtle touches of the accomplished draftsman.

132 Daumier's work, of course, was not confined to political satire, though throughout his career, at every break in the strictures of censorship, he surfaced with characteristic, biting commentaries. He is perhaps best known for several great series of city types; new species of subject befitting the urban revolution, new kinds of people both exalted and rebuked in the literature of the period. In Daumier's art they become, for all their foibles, heroes and heroines of modern life.

133 Though it is sometimes believed that Daumier's earliest work can be dated about 1822, his career in lithography begins seriously in 1830, when it was permitted, yet still perilous, to launch out into political criticism.

134 While the dates of most Daumier lithographs are easily fixed by their appearance in the press, more accurate dates, which in some cases apply to prints never published, are ascertainable through the requirements of the censorship regulations then in force. Copies of all printed matter, pictures or texts, had to be submitted for official approval before publication. The *Dépôt Légal* was the agency which registered, and dated, this material. Thus, in most cases, the *Dépôt Légal* date is closer to the actual time of execution than the date of publication. After a period of time, whether or not permission was granted for publication, the documents were deposited in the King's Library, now the Bibliothèque Nationale. It is, ironically, because of this and subsequent censorship laws, in addition to the later copyright regulations, that today, the print room of the Bibliothèque Nationale in Paris is the repository for a vast and valuable collection of works in all graphic media.

135 Among his first lithographs for *La Caricature* were parting shots at the deposed king, Charles X and his ministers, and the opening volleys at the new régime, a fusillade which was to continue unabated (though it was to take different forms) throughout the July Monarchy until its demise in 1848.

Masks

136 One of Daumier's early drawings for *La Caricature*, a kind of know-your-enemy gallery of governmental notables, was called *Masks of 1831* (Fig. 17). It appeared on 8 March 1832.

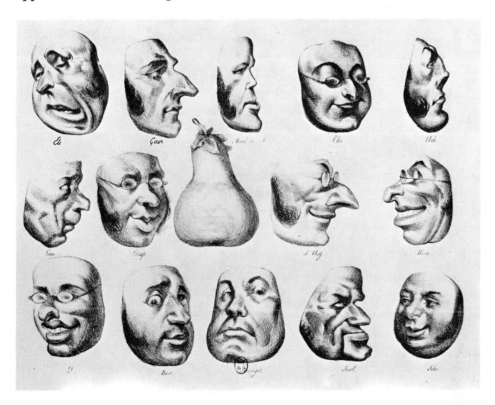

Fig. 17 Daumier. Masks of 1831. *Published in 1832.*

Can you describe two or three ways in which Daumier contrives to ridicule these representatives of the government?

DISCUSSION

Daumier's technique here is rather subtle, and not as obvious as in other lithographs you'll see. First of all, the very idea of portraying all these person-alities as masks carries with it the innuendo that the public face and the real face are two different things. There is a rather benign cast to the faces: indul-gent frowns, toothy grins, untypical of the ferocious grimaces with which Daumier adorns these people elsewhere. Behold, he says, here are the bene-factors of the people. And everyone knew what he meant. To abbreviate the names below each visage, their identifications quite obvious to any Frenchman, is a clever way of suggesting censorship when, very likely, the artist would have got away with using the whole name. Grouping all the faces together reinforces the idea of a unanimous and cohesive conspiracy on the part of the government. Its centre, a pear, with just a faint suggestion of human features, hits home just because no name accompanies it. Everyone must know who the pear is. Just to identify a few of the characters shown here: Thiers (fourth from the left); Guizot (second from left at top), politician, hostile to reform, noted as persecutor of liberals; d'Argout (fourth from left, middle row) Minister of Fine Arts and Public Works, Governor of the Bank of France; Nicolas-Jean Soult (fourth from left, bottom row), Marshal of France who had been a General under Napoleon. He became Minister of War in 1834. George Mouton Seringot (middle, bottom row), the only name fully given in the illustration, had also been a General under Napoleon. As Commander of Louis-Philippe's troops against Republican uprisings, he is distinguished in history as the first one to disperse a demonstration by the use of water from hydrants.

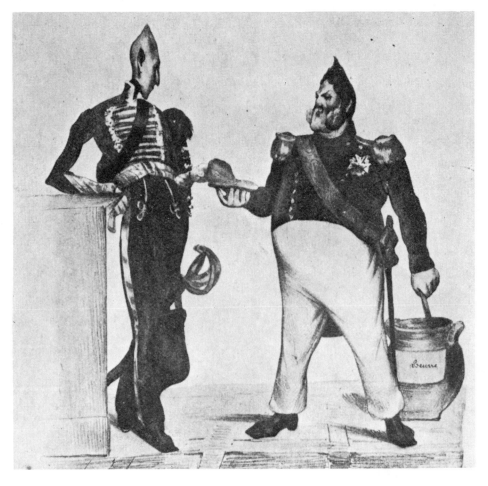

Fig. 18 Daumier. Departure for Lyons. *1831.*

Departure for Lyons

137 Compare these two lithographs by Daumier which were executed in 1831 (Figs. 18, 19). What is the main difference between them? Which one do you think was drawn later, and why?

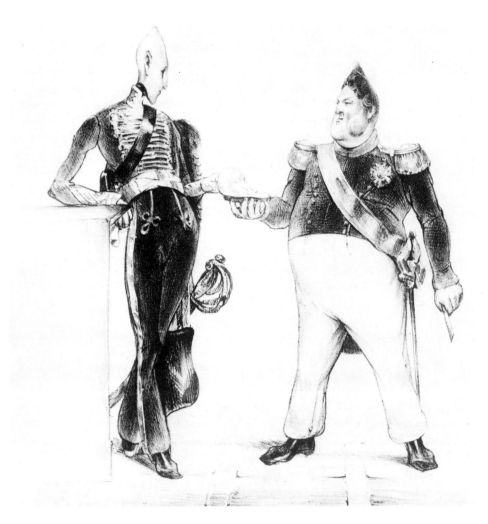

Fig. 19 Daumier. Departure for Lyons. *1831.*

138 The main difference between them is that the tub of 'butter' appears in one print but not the other. The last one drawn is that without the tub. This is probably a case where the censor insisted on the removal of the scatological reference. The *Dépôt Légal* date of the revised version is 5 December 1831. The title is *Departure for Lyons*. The caption says, 'Go ahead Poulot [a derisive nickname given by the caricaturists to Ferdinand, Duke of Orléans, heir to Louis-Philippe] and promise them a bit of what I'm giving you'. You can probably guess, in a general way, what this all means. Specifically, it is a reference to the Prince Royal's entry into Lyons with Marshal Soult at the head of a vast army on 3 December 1831 to help quell the general strike of the weavers. What new information can you gain from the dates given in this paragraph?

139 You should be able to see that Daumier executed this lithograph as a matter of urgency. Though he must have known of Ferdinand's departure for Lyons a few days before 3 December, the *Dépôt Légal* date suggests that both versions were executed within, say, a single week, in order to publish while the news was, so to speak, 'hot'. But the plate never appeared in the press. A few reasons might be suggested.

140 First of all, even the revised version may have been censored. Second, you will remember that *La Caricature* was a weekly, and by the time the changes were made in the print it may have been too late to catch the next edition and the news too stale to publish afterwards. Furthermore, the print may have been intended for distribution by itself.

G*rg*nt**

141 Figure 20 is a lithograph executed by Daumier at the end of 1831. Study it carefully. Then, in your notebook say briefly what you think it represents. How many details have you noticed which support your interpretation of the picture?

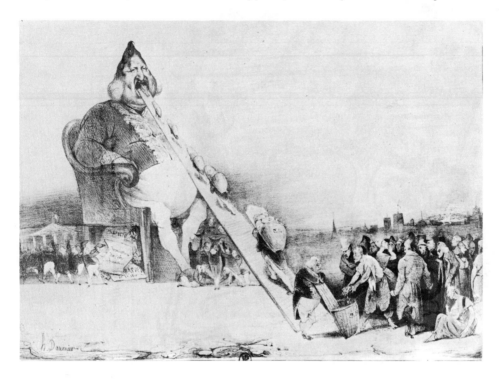

Fig. 20 Daumier. 1831.

DISCUSSION

You should have been able to recognize the colossal figure as that of Louis-Philippe from the shape of his head and body. You ought easily to have seen that some kind of tribute is being exacted from the poor and conveyed to the open, ravenous, maw of the king. Possibly you've realized that instead of a throne, Louis-Philippe sits on a commode, and that the people's money on which he feeds, carried up in sacks (in bread baskets significantly), is being excreted in the form of medals, nominations, patents, commissions, and licences. Below is a group of sycophants, hats in hand, calling out for the dispensations. They seem to emerge from a building in the distance representing, probably, the Paris Bourse (stock-exchange). Beneath the ramp, a group of men scramble about or proffer their hats for the perquisites which drop from the baskets of bounty, pointedly, even before it reaches the king. You may notice that all but the poor wear tails and knee breeches (culottes). The other men wear baggy trousers (sans-culottes). Can you see, among the poor people, a symbol of revolution? Look at the woman in the centre of the crowd. She wears a Phrygian cap. Is she Liberty? The whole is an elaborate and forthright condemnation of Louis-Philippe and the greed and corruption of his government.

142 Reinforcing the pictorial remonstration, another strata of meaning is implied by the title, *Gargantua*. Do you happen to know its source? Most literate Frenchmen of the time would immediately understand the reference to François Rabelais' wild and fantastic sixteenth-century satire, called *The Great Gargantua*. Gargantua was the parody of a crude and gross brute, posing in his own lights · as a cultured gentleman. It is full of scatological references, a central element in Daumier's picture.

143 The lithograph was executed about 15 December 1831, for that is the date on the *Dépôt Légal* stamp. Did Daumier have a particular reason for executing the picture at this time? Yes, he did. And whatever meaning we have been able, thus far, to extract from his *Gargantua* how much more pointed it must have been to the French at the time when Louis-Philippe's new Civil List (his personal budget) was debated and then approved by the Chamber of Deputies.

144 One of the few art historians who've put the magnifying glass on the *Gargantua* and its political context is Howard P. Vincent. He leads us to a very useful document. It is a bitter comment on that budget by Daumier's outspoken contemporary, the Socialist politician and writer, Louis Blanc. For the king's own expenditures he was given 18,533,500 francs. The amount, writes Blanc eleven years later, was:

> thirty-seven times greater than was paid by France to Bonaparte, first consul, and a hundred and forty-eight times greater than that which in America is deemed sufficient for the president of the flourishing republic of the United States. . . . But a Civil List of eighteen millions and more did not satisfy the court people.
>
> They must, beside, have assured to the king, as real appendages of his crown, the Louvre, the Tuileries, the Elysée-Bourbon; the castles, houses, buildings, manufactories, lands, pastures, farms, woods, and forests, comprising the domains of Versailles, Marly, Meudon, St. Cloud, St. Germain, Fontainebleau, Compiègne and Pau; the manufactory at Sèvres, and those of Gobelins and Beauvais; the Bois de Boulogne, the Bois de Vincennes, the Forêt de Sénart, to say nothing of a splendid personal endowment, comprising diamonds, pearls, precious stones, statues, pictures, cameos and other worked stones, museums, libraries, and other collections of art and science.
>
> (Vincent, *Daumier and His World*, 1968. Source: Louis Blanc, *The History of Ten Years, 1830–1840*, trans., London 1844. First pub. 1843.)

145 A preliminary Civil List was even higher. It came to twenty million francs (i.e. £800,000, an astronomical sum in those days). Even the Chamber was astonished at the amount. Louis-Philippe pretended to be disinterested in order, as Blanc writes, to appear to disavow without renouncing the List. When the List was placed under public scrutiny in the press, a great outcry arose. All the details were given. Louis-Philippe's allowance for medical attention alone came to 80,000 francs for the year, 24,000 of that (another source states) for 'remedies needful to his health'. The fact that Louis-Philippe had never been known to be ill was little consolation to his subjects. The amount of his 'pocket-money' was over four million francs.

146 Over one million was designated for the heating of the royal residences. Three-hundred horses were to be kept at a maintenance cost of 1,000 crowns each per year, an amount twice as much as a member of the Institute received.

147 Pamphlets issued by a writer named de Cormenin exposed the greediness of the List. As though describing Daumier's *Gargantua* he claimed that a heavy Civil List 'can serve no other purpose than to support in idleness the pack of bedizened mendicants, who swarm around thrones . . .'.

148 But the King had his supporters in the Chamber too, with their own peculiar theories of public wealth. All hell broke loose when one of his ministers, de Montalivet, pronounced that 'if luxury is banished from the palaces of the

King, it will soon disappear from the houses of the subjects'. A tremendous outcry arose both in the Chamber and in the Press. Over one hundred deputies registered their formal protests.

149 Notwithstanding the whole dubious procedure, not only was the List passed, but the Queen, in addition, received a dower, and Ferdinand, Duke of Orléans, the heir apparent, one million francs.

150 Even if these accounts are not taken at face value it seems to me a devastating indictment of a man who fancied himself as the benefactor of the people, wore the tricolour of the Revolution, presenting himself as the 'Citizen-King'. If you look very carefully at the print again, you may just make out on the labels of the lower two baskets the number twelve. This, most likely, is a reference to the twelfth *arrondissement* of Paris, a district in which alone, over 24,000 people lived at that time in terrible poverty. Daumier's message becomes even clearer (see Fig. 12 for Eugène Forest's comment on the Civil List for 1834).

151 Still, if you were in Louis-Philippe's shoes, or in those of his Chief Prosecutor (Jean-Charles Persil) or his Public Prosecutor (Pierre-Ambrose Plougoulm) you would probably at all costs have had the *Gargantua* suppressed. The precise details of the events which lead to the seizure of the lithographic stone and all available prints are obscure. It seems most unlikely that Daumier, aware of the offensive nature of the lithograph, would have followed the legal procedure by first submitting it for approval. Yet this, apparently, is just what he did. The police must immediately have been ordered to raid Aubert's publishing establishment.

152 Unable to print the *Gargantua*, Philipon (who probably supplied the idea in the first place) turned to words instead. He managed to skirt the edge of the law by the use of another brilliant and disarming satirical device. The article appeared in *La Caricature* on 29 December 1831, entitled '16th, 17th and 18th raids on Aubert's'.

> We have turned over 'Gargantua' again and again in every way, and we are forced to say that, of the judge who ordered the seizure, or of ourselves who do not understand the motive, one of us is a . . . (The cruel alternative in which I find myself between the truth and a new trial will excuse my lacuna.) M. Gargantua is an enormous fellow who swallows and digests very well a natural budget, which he converts immediately into secretions of very good odor at court, in crosses, ribbons, brevets, etc. etc.
>
> I have then good reason to cry to the jurors: *They will finish by making you see that resemblance there where it will not be!* For Gargantua does not resemble Louis-Philippe: he has the head narrow at the top and large at the bottom, he has the Bourbon nose, he has large features; but far from presenting that air of frankness, of liberality, and of nobility which so eminently distinguishes Louis-Philippe from all other living kings, who, just between ourselves, do not shine by those qualities, M. Gargantua has a repulsive face and a voracious air which makes the gold pieces tremble in his pocket.
>
> (trans. Vincent, *op. cit.*)

Can you imagine how those few prints which escaped confiscation, must have been shown around secretly to friends and confidants?

153 Despite the fact that the *Gargantua* had not appeared in print, Daumier, Aubert, and the lithographer Delaporte, who carried out the actual printing, were brought to trial and found guilty for inciting hatred and contempt against Louis-Philippe's government. Though defended by the capable Louis Blanc, each was sentenced towards the end of February 1832 to six months in prison and fined 500 francs plus costs. (Remember! *Gargantua* had never appeared in any journal, so the penalty must have been imposed for making lithographic prints alone.)

154 The *Gargantua* story does not end there. Even while awaiting trial Daumier, undeterred, published this lithograph (Fig. 21) in *La Caricature* on 9 February. Can you see how little was needed in the persona of the king to evoke the full meaning of the print?

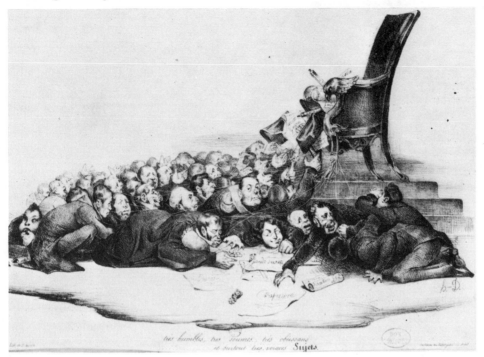

Fig. 21 Daumier. Most Humble, Most Submissive, Most Obedient. *1832.*

155 Like the symbol of the pear, which *alone* carried with it a whole range of implications, for a brief moment in history to the symbol of the 'throne' may be attributed a similar power. Just before starting to serve his prison term at the end of August, 1832, among other lithographs made for *La Caricature*, Daumier had yet another fling at Louis-Philippe using the symbol of the throne.

Daumier in Prison

156 For his impertinence, Daumier was made to cool his heels in prison, not quite for the full six months, but from August 1832 to January 1833. Nor was the whole of that time actually spent in the prison of Sainte-Pélagie in Paris. Oddly, Daumier's incarceration began about six months *after* sentence was passed, during which time he was free to pursue his career and to compound his crime by heaping further insults upon the government. Much of that time was, in fact, spent in devising a kind of rogues gallery of the leading politicians of the day, each with his mock-escutcheon in which his misdeeds are symbolically represented.

157 One of them, of Count Charles-Malo-François de Lameth, who died in that same year, appeared in *La Caricature*, 26 April 1832 (Fig. 22). Study the blown-up detail of the escutcheon (Fig. 22(a)) and say briefly, in your notebook, what general message you think Daumier wanted to convey.

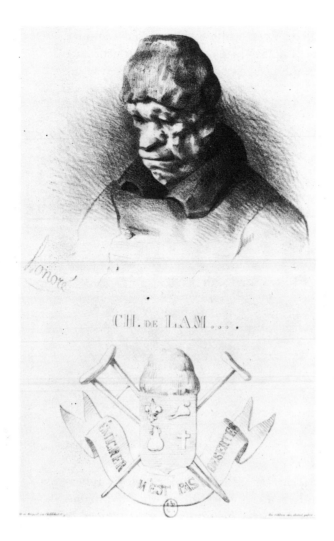

Fig. 22 Daumier. Charles de Lameth. *1832*.

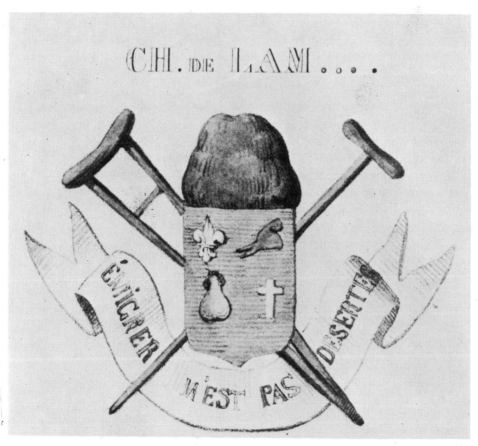

Fig. 22 (a) Detail of Fig 22.

DISCUSSION

On the shield of the escutcheon are shown the fleur-de-lis of the Bourbons, the pear referring to Louis-Philippe, the Phrygian cap of the Revolution, and the clerical cross. Lameth, to Daumier's mind, was 'a man for all seasons', having served successively the Revolution in 1789, then Napoleon, then Louis XVIII, then Louis-Philippe. He typified the upper middle class which ruled France as moderates, exemplifying the so-called 'Juste-Milieu'. His earlier career is unearthed by Daumier. The legend on the banner, '*Émigrer M'est pas Deserter*' harks back to 1792 when, as one of the first noblemen to join the revolutionaries in 1789, he left France in a hurry to start a business in Hamburg. Lameth, in fact, had been one of the liberals associated with the Orléanist faction before 1789 (see paragraph 113). You may wonder about the 'M' instead of 'N' in 'M'est', but it is very likely a deliberate mis-spelling by Daumier. It reads both 'To emigrate is not to desert' and, though grammatically odd, roughly, 'To me, emigrating is not deserting'. We may guess that the crutch and stick mean something like the propping up of all régimes.

Scissors

158 In the same series, Daumier's lithograph of Count Antoine-Maurice Apollinaire d'Argout (one of the masks you've seen in Figure 17) was published in *La Caricature* on 9 August 1832. The important symbol in *his* escutcheon is the scissors (Fig. 23). Can you guess what it represents?

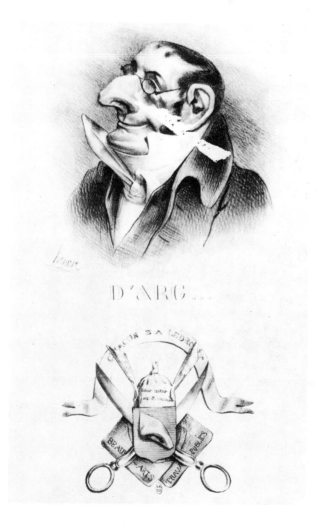

Fig. 23 Daumier. Comte d'Argout. *1832.*

159 It seems, unquestionably, to represent censorship. Count d'Argout was Minister of Fine Arts and Public Works in which capacities he exercised considerable influence on the arts. The success of any work of art hostile to the régime, or of any work by an artist known to be hostile to the régime, no matter how brilliant, was not exactly guaranteed. The use of scissors as a symbol for censorship was already well ingrained in the history of political caricature. *La Caricature* itself, in the two years before Daumier's drawing of d'Argout, printed some powerful lithographs against censorship of the press by J. J. Grandville and Forest, in which the scissors, wielded by the Chief Prosecutor Persil, form the central iconographical feature (Figs. 24 and 25).

Fig. 24 J. J. Grandville. The Shadows (*the French Cabinet*). *1830?*

Fig. 25 Grandville and Forest. Resurrection of Censorship. *1832.*

Jail

160 In August, Daumier was finally taken into custody, this almost coinciding with the beginning of Philipon's jail term ten days later. The law may have been persistent, but it would be difficult to accuse it of being vindictive. At Sainte-Pélagie, Daumier was able to carry on with his drawing, and he even succeeded in getting about fifteen lithographic stones made, on the outside, from his drawings, including yet another stab at Louis-Philippe.

Despite the letters being opened, he seems to have been free to write and to receive certain qualified visitors. A letter from prison to an artist friend is marked by Daumier's high spirits. Apart from missing his home and family, he writes:

> The prison will leave me no painful memories, on the contrary – if at this moment I had a little more ink . . . I lack for nothing. I work four times as hard inside [prison] than if I were at home . . . I am mobbed by a crowd of citizens who want me to draw their portraits.

161 The worst thing about the prison, comments Vincent (*op. cit.*), was the damp, to which a number of inmates succumbed. But Daumier, known affectionately as 'Gargantua' by the Republicans among his fellow inmates (who incidentally include all extremes of political opinion), had ample opportunity to meet and talk politics with some of the most distinguished political prisoners of the day, and the Republican newspaper, *La Tribune*, could be read there. Art, if it may be called that, was ubiquitous in prison, scratched and drawn on every available wall – a palimpsest of drawings made by generations of inmates with one new image predominating: the pear.

162. After serving about two and a half months at Sainte-Pélagie, Daumier, for reasons of health was allowed to finish out his term in a sanitorium run by Dr. Casimir Pinel, a high-minded and far-sighted champion of reform for the treatment of mental patients. Pinel's sanatorium, at his request, and with the permission of the authorities, had become a refuge for political prisoners too ill to be helped at Sainte-Pélagie. In view of the treatment of most political prisoners today, don't you think it odd that so much licence should be allowed in a French prison in Daumier's time? Why did the authorities permit such liberties?

DISCUSSION

In the uncertain politics of France in those years, and with the memory of the 1789 revolution still fresh in mind, one could never be too sure whose turn would be next. It didn't pay to become too vindictive. 'Live by the sword and die by the sword' had proven all too prophetic a warning. Floating allegiances like those attributed to Lameth were not uncommon. Often, in fact, the courts seemed rather more willing to warn than to fine and imprison offenders. Note also that at the time of Daumier's incarceration, Republican strength was growing. Not surprisingly, the chief warden of Sainte-Pélagie, a man named Prat, was distinguished for his leniency towards political prisoners, though severe with ordinary ones. He tried to avoid trouble wherever possible. The fate of the Governor of the Bastille was probably a vivid piece of history in his mind. Louis Blanc comments that Prat was 'easily alarmed by anything that foreboded

riot, for he was averse to have recourse to the bayonet; besides, some of the prisoners acquired great influence over him'. Blanc even states that the Prefect of Police, the notorious M. Gisquet, whose men so frequently raided Aubert's shop, 'did not refuse, when occasion offered, to mitigate the condition of the prisoners; such of them as had need of a few hours of liberty for important business more than once obtained permission from him to go out without escort . . .'. But, Blanc adds, 'The moderation of the superior officers was frequently neutralized by the brutality of their subalterns, and the prisoners were then subjected to the most odious treatment'.

Incident at the Bourse

163 In 1834 a law was passed making it compulsory to obtain authority from the police, before any writings or prints could be hawked or distributed in the public streets. On Sunday, 23 February 1834, prints were being sold in the Square of the Bourse, presumably without permission. A large crowd described as 'orderly' gathered there and included the usual Sunday strollers. Suddenly, the gates of the Exchange were thrown open, from which emerged police agents disguised in workers' blouses. With bludgeons, they indiscriminately attacked everyone in sight including women and children. Among the wounded were members of all classes, some even attached to the government. Great public indignation arose, and the Minister, d'Argout, who was himself a spectator of the drama, was questioned in the official tribune. He admitted responsibility for the act, pleading that he had recourse to disguise the police, 'as they were the most capable of distinguishing the innocent from the guilty'.

164 Daumier recorded the event in a lithograph published in *Le Charivari* on 4 April 1834 in which d'Argout says to his brutish looking crew, 'I am pleased with you, my brave fellows' (Fig. 26).

Fig. 26 Daumier. I am pleased with you, my brave fellows. *1834.*

Now that you know the meaning of this print, what would you say was the significance of those hats which Daumier puts in the foreground?

The hats most likely were meant to convey the indiscriminate nature of the offence. The hats belong to all classes, and they include those of a woman and a child.

The Association Mensuelle Lithographique

165 The continuous harassment by censorship and the fines imposed by the Courts seriously taxed the financial capacity of *La Caricature* and *Le Charivari*. The power of these journals to incite the political passions is measurable by the laws passed to suppress them. Since there was no intention on the part of Philipon and his associates of retreating from the battle, some means had to be found to pay the fines and ensure the survival of the magazines. So it was that in August 1832 the *Association Mensuelle Lithographique* was formed, a kind of print-of-the-month club with a more or less guaranteed subscription. Twenty-four prints were issued in two years, the last in July 1834. Daumier contributed four in the first half of 1834. Most of the prints, though the same as those published in Philipon's journals, were run off on better paper with no printing on the versos. These, today, in collectors' terms, are the more valuable. One of Daumier's most powerful drawings on the theme of freedom of the press was published in March 1834 as one of the *Association Mensuelle* plates (Fig. 27).

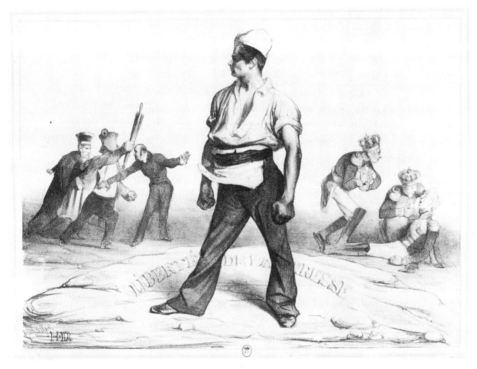

Fig. 27 Daumier. Freedom of the Press. *1834.*

166 The text and caption read, 'Freedom of the Press: Don't meddle with it!'. In the background, right, the deposed monarch, Charles X, having been given (symbolically) a knock-out blow by the powerful young printer with the clenched fists (i.e. the Revolution of 1830), is being revived by other monarchs who give him refuge. On the left, paying no heed to the plight of his predecessor, is Louis-Philippe with his attributes: top-hat, tri-coloured rosette, and umbrella which he waves as a threat. One of his more prudent ministers restrains him

while the other, the notorious Chief Prosecutor, Persil, gives him encouragement. According to Vincent (*op. cit.*), the caption, 'Don't meddle with it' (and, possibly, the picture too), is a reference to a well-known statement made before the chamber a year earlier, 'If you make war against the press, you will perish'. This was said with good reason, for one of the final acts which cost Louis-Philippe's predecessor his throne, was an ordinance (of 26 July 1830) which severely inhibited the freedom of the press, bringing an overwhelming opposition on to the barricades.

The rue Transnonain

167 One of the best known and most evocative lithographs by Daumier represents the massacre in the rue Transnonain (Fig. 28). The events leading to the tragedy form a sad commentary on the inability of the July Monarchy to maintain order yet prevent violence.

In May 1833, a revolutionary banquet at Lyons was prohibited. In October that year, the Republican *Société des Droits de l'Homme* was formed in Lyons and quickly spread throughout that part of France. The government grew alarmed. In Bordeaux and in Lyons unemployment was on the increase, due mainly to the competition from the Swiss and English silk industries. Wages dropped in consequence. The silk workers of Lyons, then in the process of organizing new workers' societies – rudimentary trade unions – went on strike on 12 February 1834. The strike failed, and the workers were back at their looms ten days later, though they grew more defiant. Urged to use stronger repressive measures, the government arrested the strike leaders and, anticipating trouble, sent in 10,000 troops. Then, acting with great recklessness, the government passed a law proscribing associations. The 291st article of the Charter, in existence even before Louis-Philippe came to the throne, prohibited any association of more than twenty persons, though it had not previously been sanctioned by the July government. *Now*, it would not only be enforced, but changed to prohibit associations of groups of even less than twenty persons, and instead of the head only being culpable, *all* members would now carry responsibility for illegal association. Feeling themselves menaced by the arrest of their leaders, and then by this law, workers in Lyons began to act in force on 5 April (the day their leaders were to be placed on trial). By the ninth, full-scale insurrection broke out.

168 That was a signal for Paris to rise in rebellion. On 13 April, sympathizers proceeded to erect and man barricades in the Marais, urged on, it is sometimes thought, by *agents provocateurs* among the police themselves in order to precipitate a show-down with the military. Determined to crush the uprising, a large number of the National Guard lead by General Bugeaud entered the quarter, were fired upon by snipers, and in retaliation, on the fourteenth, massacred several men, women and children in the building at number twelve, rue Transnonain in which the snipers were thought to be hiding.

169 The horror of the rue Transnonain had previously been enacted in Lyons, in the Faubourg de Vaise, where sixteen people in the area were taken by the military at random from their homes and slaughtered (12 April 1834). Eye-witness accounts of the brutality at the rue Transnonain were printed and widely distributed. Here is an extract from one of these accounts which precipitated a Judicial enquiry. This is the kind of document Daumier would have known:

The soldiers rushed into the passage, and, turning half round to the right, shot my husband and M. Guitard, at the moment they had reached the last step of the staircase. They fell amidst a shower of balls. The explosion was so great that the windows of the lodge, which I had not had time to shut before the soldiers ran in, were all broken to pieces. A giddiness seized me for a moment, and when I came to myself, it was to see the lifeless body of my husband stretched near that of M. Guitard, whose head was nearly separated from the neck by the numerous shots he had received. Quick as lightning the soldiers, headed by an officer, ran up to the second floor. A folding door soon gave way before them; a second door, one with glass windows, presented itself; they knocked at it furiously and it was immediately opened by an old man, M. Breffort, senior. 'We are,' he said, to the officer, 'peaceable people here; we have no arms of any sort. Do not assassinate us.' The words had scarcely passed his lips ere he fell, pierced with three bayonet wounds. He uttered a cry: 'You old ragamuffin,' exclaimed the officer, 'if you don't hold your tongue, I'll finish you.' Annette Besson rushed from an adjacent room to assist him. A soldier turned round, plunged his bayonet into her neck just beneath the jaw, and then, firing his musket at her, blew her head to pieces, the fragments sticking against the opposite wall. A young man, Henri Larivière, was following her. He was fired upon so close that the powder set his clothes in flames; the ball was buried deep in his lungs. As he was falling, mortally wounded, a bayonet stroke cut open his forehead deeply, and exposed the skull; twenty other wounds were added to despatch him. The room was already a mere pool of blood; M. Breffort, senior, notwithstanding his wounds, had managed to crawl to an alcove; he was pursued by soldiers, when Madame Bonneville came forward, and covering him with her body, her feet in the blood on the floor, her hands raised to Heaven, exclaimed: 'All my family are stretched at my feet, there remains only myself to kill, only myself!' And five bayonet wounds cut open her hands. On the fourth floor, the soldiers who had just killed M. Lepere and M. Robiquét, said to their wives: 'My poor souls! you are sadly to be pitied as well as your husbands. But we are ordered to do this, we are compelled to obey, though it makes us as wretched as you can be.'

(From records collected at the time by Charles Breffort, a brother of one of the victims, reprinted in Blanc, *op. cit.*)

170 Daumier's indignation took form in this lithograph. What does it remind you of? It reminds me of David's painting of Marat.

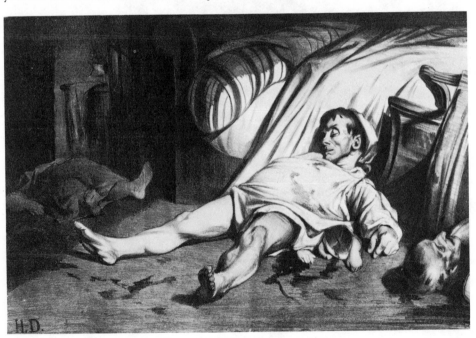

Fig. 28 Daumier. The rue Transnonian, 15 April 1834.

It is so different from his other work that Charles Baudelaire, in describing the scene not many years later remarked that 'it is not exactly caricature – but the history of a trivial and terrible reality'.

171 For some unknown reason (possibly he waited for the official enquiry to be made public) it wasn't till July of 1834 that Daumier's print was completed. When it was displayed in Aubert's shop window, crowds of people are said to have come to see it. It was at the same time published as one of the monthly contributions to the *Association Mensuelle* series (Daumier's last). Needless to

say, all available prints were confiscated and destroyed. A few survived, and Baudelaire, writing about 1851 on French caricaturists, comments on its rarity.

172 Determined to crush all opposition, the government moved to yet another extreme. About a year after the April riots a mass trial of 121 men, rounded up from all over France, was held. The proceedings began on 5 May 1835. The legal defence accorded to the indicted was outrageous, and a violation of the right of defence. They were not allowed to engage their own counsel. Official *avocats* were imposed on them; they preferred to defend themselves. Lawyers throughout the country protested. They were tried, not by men of their own rank, but, contrary to the guarantees of the Charter, by an extraordinary tribunal of a chamber of 164 peers. The trial was a farce. So illegal was it that even some of the peers protested and quit the chamber. The defendants did all in their power to disrupt the Court by making noise and using delaying tactics. Their portraits were exhibited in the streets. Biographies were distributed. The trial lasted three months. On 13 August 1835 the court of Peers passed judgements which ranged from 'transportation' to detentions of from one to twenty years and to surveillance by the police for periods of a few years to life. Daumier's wry comment on this trial, 'You are free to speak' (Fig. 29) appeared in *La Caricature* on 14 May 1835.

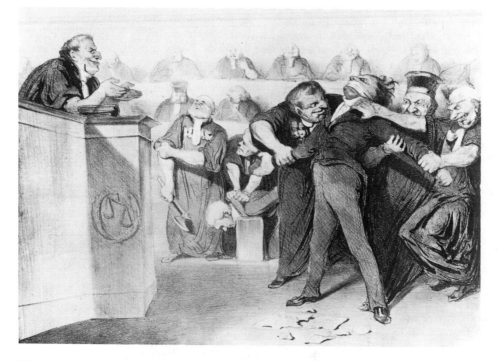

Fig. 29 Daumier. You are free to speak. *May 1835.*

Dates

173 The combination of the *Dépôt Légal* stamp (see paragraph 134) and the time of publication provides us with a secure date for each of Daumier's lithographs. Of what advantage is this fact in the study of Daumier and his times?

174 First, we have positive knowledge of the exact sequence of these works and so can map the evolution of his drawing style. That in turn may help considerably to date his paintings – often a problem for historians. Second, as with the *Gargantua*, the dates are useful in providing us with parallel historical happenings, those events sometimes containing the very key to the meaning of the lithograph itself.

175 The revolutionary calendar is, of course, full of significant dates: 14 July, 10 August, 21 January, as examples, the meanings of which you are probably aware (see chronological table in Unit 3). One might well look for the message in many contemporary satirical prints in their dates of publication. But sometimes the dates have other than political connotations. Here is one example of a Daumier lithograph in which to understand perfectly its meaning, the date of its publication must be known.

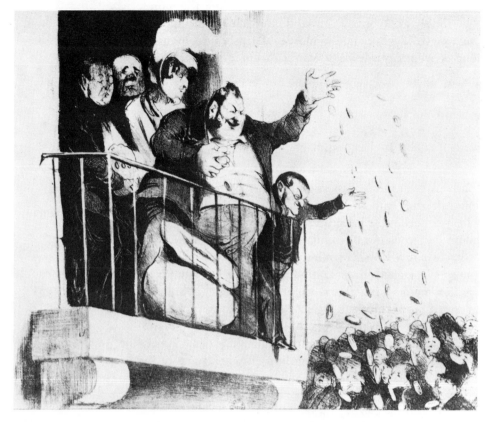

Fig. 30 Daumier.

Study the picture carefully, for part of its meaning is also apparent in the drawing itself. What do you think Daumier intended?

176 With all the abuse previously heaped upon the king by Daumier, Philipon and other caricaturists, does this not appear contradictory? Perhaps Daumier had a change of heart? Had something happened in the government? Did Daumier now see Louis-Philippe as the benefactor of the people? Does the title help?: *Here, people, here good people, do you want it? Here you are!* Louis-Philippe, and Thiers are shown showering money upon the people. Every Frenchman must have known what that signified, and if the *precise* meaning of the picture and title was not absolutely clear, the date rammed it home. What was that date?

177 Which single day of the year can you name that would give this lithograph its full meaning and restore Daumier as an implacable critic of the régime?

178 When the readers of *Le Charivari* picked up their papers that day, they may have been as perplexed as you – until they looked at the top of the page and were

reminded of the date: April 1, All Fools Day, the year was 1835. What a pleasant (or unpleasant) surprise it must have been for them.

179 Now, this example is used not only to show how clever and cutting Daumier could be, but also to demonstrate how the full meaning of a picture may depend on the *whole* of its context – even its date of publication.

180 You may already have guessed that there was something fishy about the meaning of the picture by the smug look on the faces of the men holding the money bags behind the king, by the sly and contrived abandon of Louis-Philippe and Thiers, the latter looking exactly like Punch, and most of all by the unresponsive, poker-faced crowd, none of whom reach up to catch the manna which pelts them from above.

The Fieschi Affair

181 The king must have had his gullet full of those infuriating caricatures. After Philipon's effective demonstration with the pear in 1834, and then things like this April Fool's joke, his patience must have been running out. But one event gave him the excuse he needed to clamp down utterly on his persecutors. That occurred on 28 July 1835 when a Corsican named Fieschi with a grievance against the régime attempted to assassinate Louis-Philippe during a military review – ironically one commemorating the Revolution of 1830 (a previous attempt had been made on Louis-Philippe's life in November 1833). Using a home-made contraption with an 'over-kill' capacity, a kind of 'machine-gun' with twenty-four rifle barrels mounted on a wooden frame (Fig. 31), Fieschi missed the King, wounding several others including himself when parts of the weapon burst in his face.

Fig. 31 Engraving of Fieschi and his 'infernal machine'. From the Observer, *9 August 1835.*

182 The atmosphere in which this desperate measure was taken was, it is hard to deny, in some degree created by the war waged by the caricaturists, and it is scarcely surprising that the government then clamped down heavily on the Press. In his *Memoires*, the notorious Gisquet, Prefect of the Paris police at the time, says that not only did the caricaturists commit crimes of *lèse-majesté*, but that they incited men towards assassination and regicide.

183 Louis-Philippe's first words after the Fieschi attempt were said to have been, 'Now we are sure of our majority'. But the repressive measures taken after that event did not prevent, and possibly encouraged, three more attempts at the life of the King, two in 1836, and another in 1840.

Freedom and the Press

184 Among the reforms contained in the much vaunted Constitutional Charter of the July Monarchy in 1830 was Article 7 which ostensibly abolished censorship. Strictly speaking, this was not so. The apparent moratorium on censorship had about the life-span of a gnat. And it soon became apparent that not much of an advance was made on earlier press laws, many of which remained in the statute books. A law, for example, of 8 October 1817, making it obligatory for all printed matter, textual and visual, to be submitted for approval before publication, was hardly suspended before it came again into force. This fluctuation in the law was not new. In the two decades before Louis-Philippe, censorship had periodically been abolished, then re-established, re-abolished and re-established again. And, of course, apart from a short period at the beginning of the 1789 Revolution, when freedom of the press was absolute, the censorship of Republican France was severe.

185 Not all the old press laws were pernicious, some of them necessarily dealt with matters such as copyright ('patents'), licences, and the like. But the law, in essence, remained the same as it had been under the Bourbon monarchy, the great liberal advance being, it seems, in requiring *political journals only* to deposit in advance a large sum of money as a guarantee against future fines. Gardening manuals, fashion weeklies, of course, were free to criticize the régime as they liked. Standing in contempt of the government – or the king – could result in crippling financial penalties, as Philipon well knew.

186 After 1830, new press regulations (of 1832, July and December of 1833, 1834, 1835) enlarged the Code considerably, though not all were restrictive. The law of 27 September 1833 prohibited any clandestine press. Yet that of 11 October 1833 exempted from stamp duty simple political tracts sold to the public in the streets. It was, to say the least, inconsistent. But the alarm of the government at the audacious attacks in the press, if not in the streets, by both Republican and Legitimist forces, drove them to pass the hated and much reviled press law of 9 September 1835. The government was determined to put an end to their detractors among the ranks of artists. They still insisted that Article 7 of the Constitutional Charter guaranteed Frenchmen freedom of the press. Drawings, however, were different, they said: '. . . when opinions are converted into actions by the distribution of drawings, when it is a case of speaking to the eyes, it becomes an incitement to action and is not covered by Article 7'. The demise of Philipon's magazine *La Caricature*, was directly the result of those laws.

187 The Code as published in 1836 is prefaced: 'The French people have the right to publish and to put into print their opinions in conformity with the law. Censorship will never be re-established.' Yet, following this statement, Articles 1 and 20 of the 9 September law make the preamble sound like a classic case of double-think.

> No drawing, engraving, lithograph, medal or print, no emblem of whatever type and kind, is to be published, exhibited or put on sale without prior authorization from the Ministry of the Interior, in Paris, and the Prefectures in the departments.
> In the event of contravention, the drawings, engravings, lithographs, medals, prints or emblems will be confiscated, and its publisher will be sentenced by the court, to an imprisonment of one month to one year and to a fine of 100 to 1,000 francs, no matter what suits the publication, exhibition and sale of the aforesaid objects may give rise to (Article 20).

Article 1 says:

> The necessary authorization required under article 19 in the law of 9th September, 1835, will contain a summary description of the drawing, engraving, lithograph, print or emblem that the applicant wishes to publish, and the title which he intends to give it. The author or publisher will be obliged to indicate its form on all requests, be it engraving, lithograph, print or emblem that are to be reproduced in quantity; the author or publisher, on receipt of the authorization, will deposit with the Ministry of the Interior or the office of the Prefecture, a proof for purposes of comparison; he will guarantee the conformity of this proof with those that he intends to publish.

188 Just to make sure you grasp the implication these laws had for the caricaturist, imagine Philipon or Daumier going through the proper motions (the legal ones) and the ways in which doing so might affect their drawings. Will you put these down, step by step in your notebook?

DISCUSSION

I see it happening like this:

1 Daumier gets an idea, not very complimentary to Louis-Philippe, to be published in one of the satirical journals.
2 He goes down to the Ministry office and fills in an authorization form.
3 On it he tries to describe his picture in words (a difficult thing to do) and gives it a title.
4 He returns a few days later to see if the authorization is granted.
5 Assuming that it is, he goes home to complete the drawing, and inevitably a few changes creep in.
6 He carries the stone to the printer's, and takes a few proofs from it.
7 He returns to the Ministry to deposit a proof but this is rejected as it does not appear to match the verbal description. The official involved suggests a few alterations.
8 The procedure is repeated, and a new proof is submitted. Meanwhile the deadline draws near with no guarantee that the 'corrected' drawing will be acceptable.

Daumier actually went through similar processes, having to alter his drawings for the Ministry watchdogs. Can you see why he and Philipon were willing to take so many calculated risks, inviting fines and imprisonment; and why, after the 9 September law, *La Caricature* had to fold up?

189 If you look at any collection of caricatures of the period, or if you search through the pages of *Le Charivari* you will be struck by a great fissure in politically-directed caricature between 9 September 1835 and 24 February 1848 when the July Monarchy had run its course and Louis-Philippe was forced to abdicate. That gap, despite the severe restrictions on artists – and even, possibly, because of them – was one of the richest periods of satire in the whole history of caricature. Think of what you might do if you were in Philipon's or Daumier's shoes? How would you contrive to continue the battle without exposing your flank – so to speak?

Enter Robert Macaire

190 A golden opportunity for satirical caricature presented itself in the form of one of the greatest rascals ever to be devised by the combined power of the arts: the fictitious, but oh! so real, character called Robert Macaire. Macaire was the perfect answer for the satirists. He came to life in 1823 as an amoral scoundrel

with the gift of the gab, in a second-rate melodrama by a little known team of three playwrights. It was called *l'Auberge des Adrets* (The Inn of the Adrets). Macaire was one of a pair of fast-talking thieves who'd escaped from the galleys. But there was nothing larger than life in the way the character was conceived until the great actor Frédéric Lemaître made it vital by casting Macaire in a satirical mould (Fig. 32).

Fig. 32 Frédéric Lemaître in the role of Robert Macaire. Drawing by A. Lalauze after a photograph.

191 Lemaître made Macaire into an archetypal swindler, a fraudulent villain, as an instrument of criticism of French society. When Lemaître's Macaire was suppressed, Daumier took up the cudgel. Every corruption in commercial speculation, the granting of special privileges, fiddling with the funds, cheating in contracts, underhand profits, every conceivable peculation was laid at the feet of Monsieur Macaire. Daumier conceived of Macaire in his own way. He executed over one hundred lithographs between 1836 and 1838 (and others later) in which this artful rogue figured. Philipon wrote the captions. The physical attributes of Lemaître's Macaire were as threadbare as his social convictions. Lemaître's Macaire was depicted as a run-down vagabond with

patches on his clothes, a dirty green coat and crimson trousers. A battered old hat was pulled down over one eye, and a patch covered the other. He sported a cane as thick as a club, and a snuff-box. But Daumier's Macaire was different. Not confined to the physical type of a single actor, Daumier's Macaire came in several guises, the better to give him the plurality of meaning intended – to make Macaire universal in his corruption (Fig. 33).

Fig. 33 Montage of Robert Macaire in different roles. From lithographs by Daumier, 1836–1838.

192 For Daumier and Philipon he is a stock-broker. He is also a barrister and a solicitor. Robert Macaire is a notary public, a matrimonial agent and a Bible salesman. Wherever there is double-dealing or hypocrisy, there too is Macaire.

193 Among the first representations of Macaire by Daumier and Philipon, was one daringly reminiscent of Louis-Philippe himself, Macaire masquerading as the king. Macaire had his pantaloon, Bertrand, and as Thackeray says, as in all good pantomimes, whatever blows were destined for the clown, Macaire, fell instead on the head of Bertrand. Whenever the clown robs, the stolen articles were sure to be found in his companion's pocket.

194 Macaire was an immense success, and his meaning was not lost on the population of France. This success may be gauged by the fact that in 1839 and 1840 the whole series of 101 plates which had appeared in *Le Charivari* was accurately redrawn in smaller size (a formidable task) and published by Aubert as a book with a text by P. M. Alhoy and L. Huart. The expense involved in an enterprise of that dimension would hardly have been risked if substantial sales were not virtually guaranteed. Other prints from the Macaire series were published in sets of fifty and eighty in 1837 and 1838. At the end of 1838 portfolios both in black and white and in colour were available. The series was pirated in Belgium, and in 1842 a charming little pocket-sized book appeared, *Physiologie du Robert Macaire*, in which the culprit is described in twenty-two different guises.

195 Macaire's epigrams were so close to the bone, and yet relatively safe from censorship, that, according to Thackeray, 'it was a blow that shook the whole

dynasty'. After the September Laws, such satirical innuendos had to be made more by analogy: indirect, and aimed anywhere else, but not at the government. Robert Macaire, says Thackeray, may have been driven out of the chambers and the palace, but the rogue had all the world before him from which to choose, and there he found no lack of opportunity for exercising his wit. And so we get Daumier's court scenes, with its unscrupulous lawyers and obtuse judges; in his exposure of all the financial skulduggery of the Bourse, the medical profession, the world of fashion, no aspect of professional life under the July Monarchy evaded his scrutiny.

196 Robert Macaire had all these to exploit, says Thackeray. 'Of all the empire, through all the ranks, professions, the lies, crimes, and absurdities of men, he may make sport at will; of all except a certain class. Like Bluebeard's wife, he may see everything, but is bidden to beware of the blue chamber. Robert is more wise than Bluebeard's wife,' continues Thackeray, 'and knows that it would cost him his head to enter it. Robert, therefore, keeps aloof for the moment. Would there be any use in his martyrdom? Bluebeard cannot live for ever; perhaps, even now, those are on their way . . . that are to destroy him'.

197 And so, that uncertain satirical borderland between the innocuous and the injurious had to be trodden by Daumier and his friends. Though Thackeray sees Macaire and his 'straight man' Bertrand as universal types, to be found in London as well as in Paris, he points to the plethora of commercial enterprises in France at the time: newspaper companies, bitumen companies, railroad companies, galvanized iron companies which are 'pursued with such a blind *furor*, and lust of gain . . . that, as may be imagined, the satirist has found plenty of occasion for remark, and M. Macaire and his friend [are given] innumerable opportunities for exercising their talent'.

198 Thackeray mentions a scandal of the day, the shady activities of Emile de Girardin, a dyed-in-the-wool monarchist, owner of a frankly monarchist newspaper, and speculator in shareholdings with other people's money. 'Could Robert Macaire see such things going on', he says, 'and have no hand in them?' No, Macaire could not.

199 Thackeray describes the first print in his collection in which Robert explains his projects to Bertrand (Fig. 34). 'Bertrand', he says, 'I adore commerce'. 'If

Fig. 34 Daumier. Plate I from the Robert Macaire series, Bertrand, j'Adore l'Industrie.

you'd like we'll open a bank, but a real bank: capital one-hundred million, million – one-hundred thousand million, one thousand million – shares. We'll break the Bank of France, we'll break the bankers, we'll sink everyone.' 'Oui', says Bertrand, very calm and stupid, 'but the gendarmes?' 'You're a fool, Bertrand', says Macaire, 'Who's going to arrest a millionaire?' Such is the key, writes Thackeray, to Monsieur Macaire's philosophy; and a wise creed too, as times go.

200 Now, Louis-Philippe was solidly entrenched. But there were rivalries in his ministries – often encouraged by him for his own ends – and no real political unanimity other than a resistance to change. In this period between the press law of 1835 and the 1848 Revolution, corruption between government officials and business interests was rampant. Scandal broke upon scandal, added to which the declining financial health of the country and the depression of 1846–47 and, concomitantly, the demands for universal suffrage, helped to bring to the surface the subcutaneous republicanism which with a new voice erupted against an unresilient Louis-Philippe and his minister Guizot, who inevitably in 1848 succumbed. In the Revolution of 1848, the fragile situation only needed the circumstance of troops firing on the protesting crowds to bring the government down.

How artists responded to the 1848 Revolution is the subject of the radio programme which completes this unit.

ACKNOWLEDGEMENTS

Grateful acknowledgement is made to the following sources for material used in these units:

TEXT

Ancienne Librairie Germer Baillière et Cie., for F. V. A. Aulard, *Le culte de la raison et le culte de L'Être Suprême*, 1904; Collins, Fontana Library for A. Sorel, *Europe and the French Revolution*, 1969; J. Droz, *Europe between Revolutions 1815–1848*, 1967; T. Fisher Unwin, for F. V. A. Aulard, *The French Revolution*, 1910; North western University Press for H. P. Vincent, *Daumier and His World*, 1968; Oxford University Press for G. Rudé, *The Crowd in the French Revolution*, 1967; Penguin Books for H. Balzac, *Cousin Bette*, 1965, A. Cobban, *A History of Modern France* and H. Honour, *Neo-classicism*, 1968; Routledge & Kegan Paul for J. Lemprière, *A Classical Dictionary*, 1908; La Table Rotonde for L. Hautecoeur, *Louis David*, 1954; University of Chicago Press for H. Parker, *The Cult of Antiquity and the French Revolution*, 1937; University of Nebraska Press for D. Dowd, *Pageant Master of the republic: J.-L. David and the French Revolution*, 1948.

ILLUSTRATIONS

Bibliothèque Nationale for Figs. 13, 17, 19, 20, 21, 22, 23, 26, 27, 28, 29, 30 and 34; British Museum for Fig. 7; Louvre for Fig. 1, Plates I and III; Mansell Collection for Figs. 11 and 32; Marillier Collection for Fig. 18; Musée des Beaux-Arts, Dijon for Fig. 2; Musée National de Versailles et des Trianons for Fig. 4; Musée Royaux des Beaux-Arts, Brussels for Plate II.

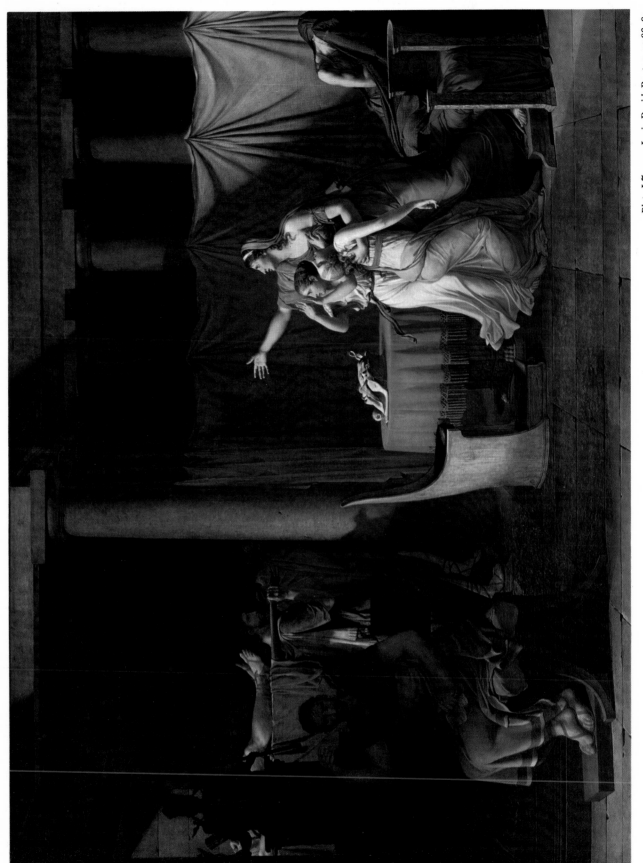

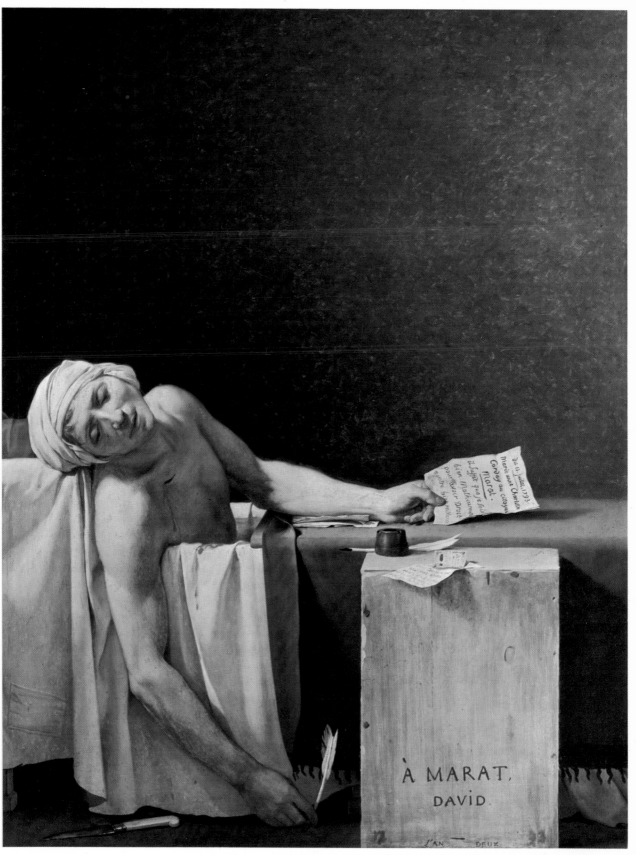

Plate II David. Marat Assassinated. *1793*.

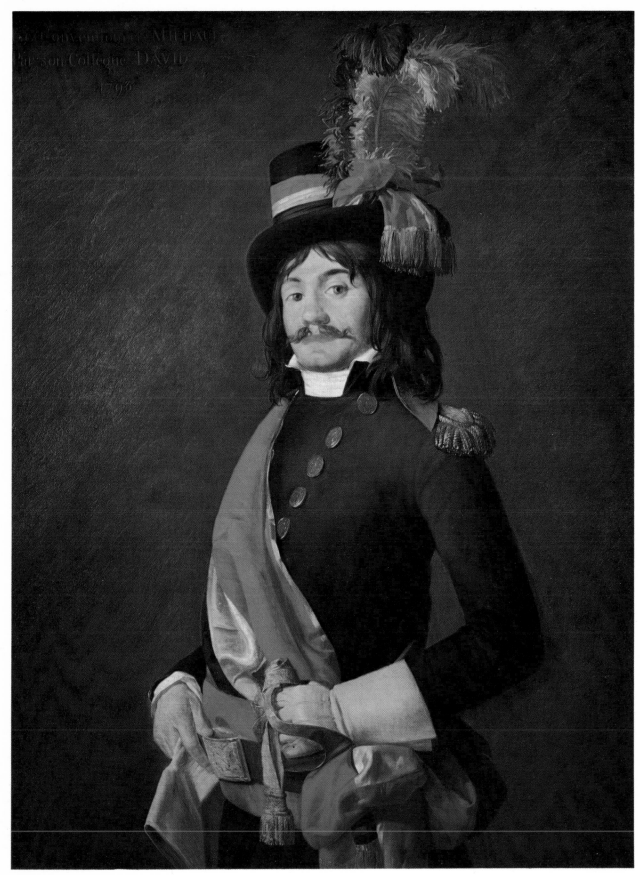

Plate III The Deputy J. B. Milhaud painted probably by David's students in 1793.

THE AGE OF REVOLUTIONS

A Study Guide to Stendhal's *Scarlet and Black*